THE
CARTOONIST'S
BIBLE

THE CARTOONIST'S BIBLE

AN ESSENTIAL REFERENCE
FOR THE PRACTICING ARTIST

Franklin Bishop

CHARTWELL
BOOKS, INC.

A QUARTO BOOK

Published in 2006 by
Chartwell Books
A division of Book Sales, Inc.
114 Northfield Avenue
Edison, New Jersey 08837, USA

ISBN-13: 978-0-7858-2085-7
ISBN-10: 0-7858-2085-X
QUAR.CARB

This book was designed
and produced by
Quarto Publishing plc
The Old Brewery
6 Blundell Street
London N7 9BH

Project Editor *Mary Groom*
Art Editor *Julie Joubinaux*
Designer *Karin Skånberg*
Assistant Art Director *Penny Cobb*
Art Director *Moira Clinch*
Publisher *Paul Carslake*

Manufactured by *Modern Age
Repro House Ltd, Hong Kong*
Printed by *Midas Printing
International Ltd, China*

CONTENTS

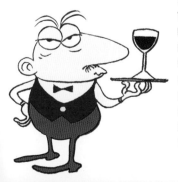
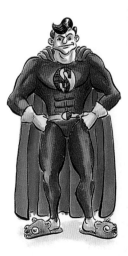

INTRODUCTION

Being able to draw cartoons is one of the great pleasures of life. Cartoons are fun to draw and give enjoyment to others who see them. We are all born with a natural inclination to draw or make images on paper and it is up to each individual to either develop it or let it stagnate and disappear. If you have always wanted to be a cartoonist, or if you need practical advice to improve your cartoon drawings, or even if you hope to become a professional cartoonist then this book will provide you with everything you need to know, from the basics of cartoon drawing to insider hints and tips from a professional cartoonist—everything in fact that will help you to maximize your own unique cartooning skills.

Find out about tools and materials

The contents of this book are unique and completely practical. Not only will you learn how to draw cartoons in many formats including up-to-date advice on CGI (computer generated images) and Manga comics but you will learn easy, foolproof methods of how to always be able to think up new humorous ideas for cartoons and how to give yourself the best chance of selling your work and seeing it published.

Learn how to use basic techniques and styles

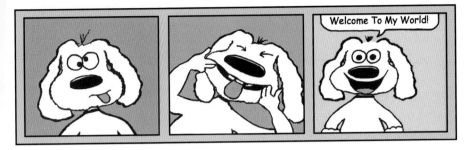

There are many books on cartooning but this one is exclusive in that it gives you the priceless benefits of a professional cartoonist's insider hints and tips that would take years of hard work to learn on your own. There are lots of clear "how-to-do-it" sections carefully designed to encourage and develop your drawing skills plus lots of trade secrets about cartooning direct from an expert to give your cartoons the "wow!" factor. There are explanations of the various types of cartoon work including the growing popularity of comic strips and the ever-increasing demand for cartoons for greeting cards. Learn how to find little-known niche markets for your cartoons that you never realized existed.

There is also an extremely useful and comprehensive Expressions File that means you will never struggle to draw just the right look on your cartoon characters! Also included is a valuable Cartoon Resources file to signpost you on to further information about all aspects of cartooning.

Look at the possibilities provided by new media

WHAT IS A CARTOONIST?

Can you spot a cartoonist in a crowd? What does a cartoonist look like? Tall or short? Male or female? Short or long hair? Are they rich? Do they have a college education? Where do they live?

The truth is that every cartoonist is different and an individual. That is the great thing about becoming a cartoonist—anyone can learn to draw cartoons provided they have the desire and willingness to learn. You may not end up becoming a millionaire or world famous (although who knows!) but you could certainly find that you have a real skill to entertain yourself, your family, and your friends, and perhaps you will even see your work published and be paid for it.

This book offers a practical storehouse of knowledge about all the skills of cartooning. You do not need any special artistic ability to become a cartoonist—you just need a love of drawing, enthusiasm, and a willingness to have fun. Every cartoonist was once a complete beginner. We often start off in life as incredibly uninhibited cartoonists—and then as we grow up we allow our natural skill to wither away as we face criticism and are pressurized to learn more "practical" skills in order to get a job and make our way in life. Rediscovering those lost and natural cartooning skills of our early years can be a very enjoyable experience and this book will show you how to do this.

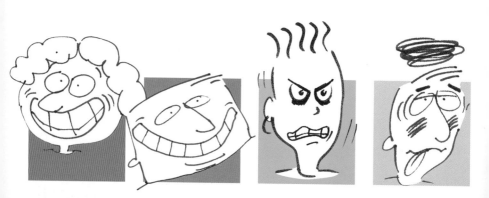

So what is a cartoonist in the modern understanding of the word? What does he/she do? The word originates from "cartone," which was the name of a pasteboard the Italians used to make a full-size drawing for wall paintings in the fourteenth and fifteenth centuries. It was some 250 years ago that satirical drawings and caricatures began to be called cartoons.

Cartoons create a blend of picture and idea that is unique and does not really work in any other format. Most cartoons are humorous in as much as they tell a joke. They make us laugh but they can also be serious and make political points, powerfully summarizing a situation that would require hundreds of words to explain.

Cartoons are increasingly popular and we find them everywhere—in advertisements, on TV, in newspapers, books, movies, and magazines. They make us laugh and stimulate our brains. We grow up reading cartoon books and watching cartoon characters on TV—they form an integral and influential part of our life. Imagine how much more thrilling it will be to be able to draw your own cartoons.

Begin the adventure!
Become a cartoonist!

CHAPTER ONE

TOOLS AND MATERIALS

GETTING TOOLED UP

The great advantage of being a cartoonist is that you do not need to spend a fortune on expensive equipment or materials. Ultimately all a cartoonist needs is something to draw with and some paper to draw on.

Of course, to be able to draw with consistency you will need a good supply of pencils, pens, and some decent paper. As you gain new drawing skills you will decide on just the right drawing implements that suit your style and your favorite type of paper. Cartoons can be produced in all kinds of media, techniques, and styles, but it is a good idea to start with black-and-white drawings. As you gain confidence, you can move on to explore color and a wider range of more advanced and sophisticated drawing tools, including the many possibilities of computer-generated cartoons (see Using computers, page 30).

Scalpels

Scalpels are invaluable for trimming your artwork and much more accurate than using scissors. Scalpel handles and packs of blades are easily available from art materials stores.

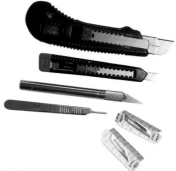

Light box

A light box is simply a lit screen that enables you to see through opaque paper and original artwork so that you can trace and amend the drawing on a new sheet of paper. These are not essential and can be expensive but they are useful if you intend to be a professional cartoonist. Sizes range from A4 tabletop boxes upward.

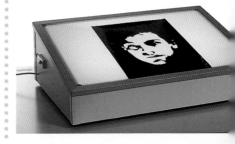

Drawing board

These can vary from a simple piece of plywood to a purpose-made, freestanding drawing board complete with an attached parallel motion device. If you don't have the space for a large freestanding drawing board, a fold-flat tabletop drawing board can be particularly useful (a good size to start with is A3). To complement your drawing board you will also find it useful to have a set square since this, together with a T-square, will allow you to set up your artwork accurately. Throw in a ruler too and your drawing board will be ideal for efficient working.

Cutting mat

To avoid leaving nasty deep scratches over your tabletops or drawing board a cutting mat is another desirable item to have—it is simply a plastic mat that stops the blade cutting through to the surface below when you are trimming paper or card to size.

Miscellaneous items

Drafting tape is low-tack and is great for sticking down your paper onto the board while still allowing you to remove it without damaging or tearing the sheet. A dry glue stick is incredibly useful for a cartoonist especially if you are putting a patch of paper over your original artwork with a correction on it. Process White is an item used by professional cartoonists. It is a thick, opaque pure white type of paint that is used to cover up mistakes on original artwork and allows you to draw over it.

A WORKING SPACE

It is a fact that cartoons can be drawn in just about any place you care to think of, but if possible, do try and get yourself a set area or room in which you can work without too many distractions such as pets, children, and loud music (unless you happen to work well in such an environment).

A coffee table is usually good enough to start with, or if all else fails then you can set up shop on your lap! As you acquire more and more pens and paper and other cartooning equipment you will find yourself needing more space in which to work successfully so plan ahead and mark your territory from the start! Your own cartoon-dedicated work space will become absolutely essential and will help you to get in the right frame of mind for producing cartoon work whenever you are there.

Wherever you decide to set up your working cartoon space try and have some shelves nearby for all the books and files you will inevitably acquire. It is also very convenient to have a storage area for your paper since there is nothing worse than constantly having to stop and find some paper from elsewhere just when you are in the middle of a creative flow! A filing cabinet for storing in logical order all of your finished cartoons is also a great asset.

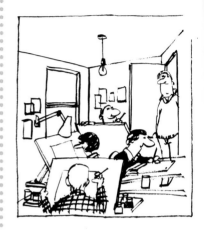

Many possibilities

Where you work will depend on where you feel happiest and most at ease. You may only feel happy in a large space overlooking a captivating view. But perhaps this would give you agoraphobia and you may prefer the bustle of a kitchen table. If working at home disagrees with you, try renting space in a graphic design studio.

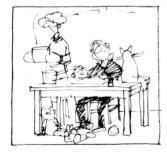

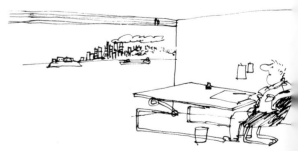

Creating a good working space

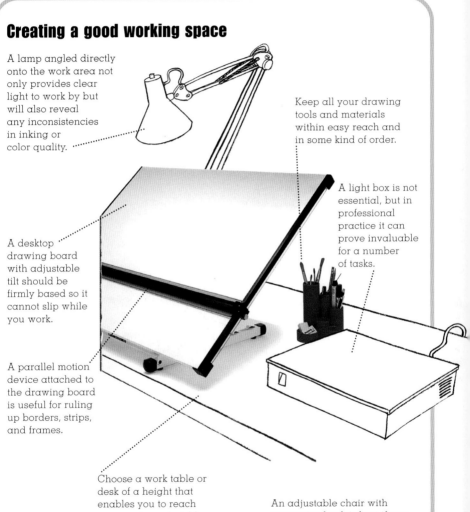

A lamp angled directly onto the work area not only provides clear light to work by but will also reveal any inconsistencies in inking or color quality.

Keep all your drawing tools and materials within easy reach and in some kind of order.

A light box is not essential, but in professional practice it can prove invaluable for a number of tasks.

A desktop drawing board with adjustable tilt should be firmly based so it cannot slip while you work.

A parallel motion device attached to the drawing board is useful for ruling up borders, strips, and frames.

Choose a work table or desk of a height that enables you to reach your work comfortably, without stretching or slouching.

An adjustable chair with supportive back is best if you are going to be spending long hours working out ideas and concentrating on finished work.

THE PENCIL

The pencil is the most basic, and perhaps the most important, drawing instrument for a cartoonist. It is perfect for getting ideas down on paper and for sketching out your characters, backgrounds, and settings before inking over and coloring. A pencil is easy to carry around to record notes; it lends itself to sketching and rough work, and can always be easily erased if mistakes are made. Once drawn to your satisfaction, a penciled cartoon can then be inked over and, when the ink is dry, any remaining pencil marks erased.

Monochrome media

Most cartoonists use graphite pencils—soft lead (marked B series) are good for dark lines, while H series make lighter lines. Try a combination HB pencil to combine the best qualities of the two types. Graphite sticks are shaped like pencils without the covering of wood—try the all-round grade of 2B.

Making marks isn't everything; you will also need erasers to remove some of them. Avoid erasers that are gritty or smear the pencil lines; always buy good quality flexible white erasers that remove marks without abrading the paper.

Colored pencils

Colored pencils are very easy to draw with and, unlike watercolors, they are easy to carry around to make sketches on the spot. There are two basic types: both can be used directly on paper, but the water-soluble kind can also be used to create color washes to achieve an effect that is very similar to watercolor.

HOT TIP!

When you are sketching cartoon ideas it is best to use a pencil (HB series) for directness and spontaneity of line.

Erasers
White plastic erasers clean up marks without abrading the paper surface.

Pencils
Good-quality pencils have properly defined grades and even-grained wood casing.

Mechanical pencils
Mechanical pencils are designed for technical use and so make a standard-width mark.

Graphite sticks
Some graphite sticks are coated in lacquer, but thicker uncoated sticks give faster sideways use.

Ungraded pencils
Soft, black, ungraded pencils have large diameters and thick leads, and are useful for broader work.

Pastel pencils

Pastels have a soft, brittle, dusty core that makes a matte mark. The marks generally need to be fixed (sprayed with a chemical that stops it from rubbing off). These can give lots of subtle color effects. Using colors in cartoon drawings can result in very distinctive results and are well worth experimenting with.

Graphite pencil is a sensitive medium allowing variable line and shading.

A mechanical pencil has a finer, more consistent touch because of the narrow lead.

INKS

The majority of cartoons that you see published are drawn with ink. Ink-finished cartoons are the most easily reproduced for the printing process in magazines, newspapers, and books. However, using dyes is another option to consider—these are very fine liquid colors with nothing added, so you literally dye the paper you are coloring.

A fountain pen handles easily.

A technical pen is designed to provide a fine, consistent line.

Dip pens are versatile and work well, once you learn how to handle them.

Types of ink

The most important aspect of black drawing ink is whether or not it is waterproof. The dried ink line work must not be soluble if you are going to apply color washes over your cartoon. India ink, also called "encre de Chine," is the best to use but make sure it is fully waterproof as some specially ground non-waterproof types are sold under the same name. Always buy a large bottle—it is more economical and means you will not run out of ink in the middle of a drawing. Colored inks also need to be waterproof to avoid reacting with any black ink line work.

Using pens

The traditional dip pen is still used by some cartoonists because it gives a very individual mark on the paper, but they can be difficult to master. Nibs tend to wear out and break, and they can be very messy in inexperienced hands. Fountain pens can be used for cartooning and give most of the advantages of a dip pen without the worry of dripping ink accidentally over your valuable artwork. Technical pens have also been developed that give a consistent line in graphic work and vary in thickness—but they do not lend themselves to expressive drawing and can produce very mechanical looking line work.

Non-waterproof ink Writing ink Drawing pen ink

An old brush that has splayed is still useful.

For washes of tone and color, choose a large roundhair brush from a watercolor range.

A cotton swab is an excellent tool for laying solid colors.

Using brushes

Brushes are the most expressive way of applying ink but they are not every cartoonist's favorite due to the difficulties in mastering the technique of drawing with a brush. However, they are excellent for applying a background wash to cartoons and add depth and tone to black-and-white drawings. You need to keep two types of brush, one for drawing and another for applying color. Sable brushes are expensive but the most responsive and expressive in use. The cheaper synthetic and acrylic/sable mixed brushes are not so supple. Use an acrylic brush for filling large areas of black or you could (as some professional cartoonists do) use wads of cotton or bits of a sponge dipped in ink and dabbed over the paper instead.

Brushes for drawing must be good quality types that are flexible and maintain a clean point, in order to produce a clean, effective line.

PENS

The fiber-tip pen has become an essential part of the cartoonist's drawing armory. Available in a wide range of sizes and shapes and charged with different inks of all colors they can be used for a great variety of cartoon work.

The opaqueness of the black and the range of colors gained from using a fiber-tip pen are particularly suitable for reproduction. The alcohol-based ink generally used has the benefit of drying very rapidly, thereby reducing the possibility of smudging your artwork. But the real attraction of using fiber-tip pens in cartoon drawing is their immediacy—they are quick and easy to use and generate spontaneous line work. They also allow you to draw delicate detail in a cartoon. The fiber-tip pen (as opposed to traditional ink pens with hard-to-control and often unreliable nibs) has liberated the cartoonist from worrying about the drawing instrument and allows full focus to be placed upon the drawing itself.

One drawback to using fiber-tip pens is their relatively short lifespan as the tip loses its definition and shape and the ink dries up.

Markers are available with wedge- or chisel-shaped tips, thick bullet points, or fine fiber-tips. They are comfortable for free, simple cartooning styles and a thick tip gives a lively directional line.

When you want to apply color to a large area of your cartoon choose a fiber-tip pen with a large chisel-shaped tip. It can be difficult to get a consistent block of color using a fiber-tip pen and it takes practice to gain confidence in using them, but for black line work a fiber-tip pen is ideal.

The fiber-tip pen lends itself well to applying color to cartoons because it is less messy and quicker to dry than watercolors or gouache. However, problems can occur when laying one color over another so make sure that you test them on a separate piece of paper before you start. Applying small areas of color detail with fiber-tip pens can be more difficult so it is important that you familiarize yourself well in advance before coloring in your cartoon original.

There is little that can be done to prolong the life of a fiber-tip but taking care to replace the cap after use will help. Always have a few spares at the ready so that you don't find yourself with a dried-out pen in the middle of drawing a cartoon.

TECHNIQUES

Always use fiber-tip pens with an alcohol-based permanent black ink for drawing line work in your cartoons. This will ensure that if you want to apply color to your cartoon the black line work will not mix and smudge.

Ballpoint pens

Ballpoint pens are simple to use and produce a surprising variety of line but they are not commonly used for printed cartoon work. However, non-clogging and smooth flowing ballpoint pens can be marvellous to draw with so it is well worth experimenting with them to see if they suit your cartoon style. All these examples (left) were produced using varying types of ballpoint pens.

GOUACHE

Color in cartoons can add life and interest so it is important to get to know the various mediums and techniques available. Gouache is watercolor paint with the addition of white pigment. It is ideal for producing large areas of flat, even color to which, when dry, can be added extra detail. It can be used in thin washes or applied in thick, opaque layers. It is thicker and more flexible than watercolor and its smooth texture means that it reproduces well in print and can be used on colored paper.

Why use gouache?

Gouache comes in tubes or plastic tubs and is cheap to use if you limit the size of your cartoons to fit onto A4 or A3 paper.

Using gouache

This color cartoon by Clive Collins makes clever use of the "negative" white line contrasting with the black keyline drawing and bright gouache color. It attracts the eye and leads into the joke. The carefully drawn fence establishes depth, while the grassy texture comes from marker strokes overlaid with wash.

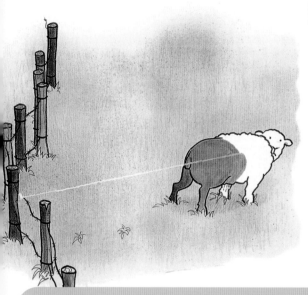

Important properties of gouache

Permanence

The permanence rating is usually given on the tube and indicates the durability of the color, i.e. how likely it is to fade.

Opacity

Most colors are opaque but some, like bright yellow, are not.

Staining

Some gouache colors will bleed through any color put on top of them so be aware of this before you ruin your artwork.

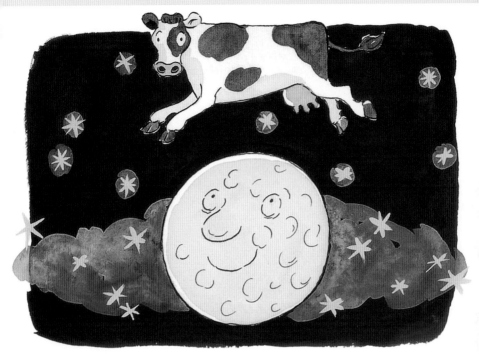

Vivid contrast

The strong colors of gouache paint mean here that the dark sky contrasts vividly with the lighter moon and cow. Gouache is an excellent medium to use in illustrations for children's stories because it is so bright and vibrant.

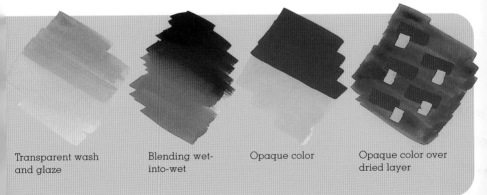

Transparent wash and glaze

Blending wet-into-wet

Opaque color

Opaque color over dried layer

WATERCOLOR

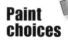

Watercolor is a friendly medium for beginners, but a difficult one to master. The main characteristic of watercolor is that it is transparent and can be used very wet. It is one of the most expressive and beautiful mediums with lots of different techniques used to achieve various effects. In cartooning it is often used on black-and-white line drawings as a wash of gray tone to add atmosphere and depth. A cartoon in black line work can also have added tone on selected areas by applying a diluted ink wash.

Paint choices

Watercolors can be bought in tubes or as small solid blocks often sold in boxed sets with a wide range of colors available.

Brushes

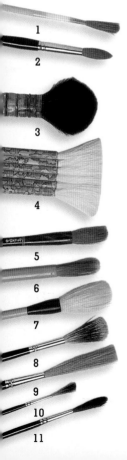

Brushes intended for pottery or painted effects (1–4) can be used for drawing with ink or watercolor. Inexpensive Asian brushes (5–8) are excellent, so long as the hairs don't shed. The brown-haired types have some point when wet; the white-haired ones are limp and are used for washes. A squirrel mop and good sable brushes (9–11) are a major investment.

Ink wash

An ink wash has been used to give depth to the woman's skirt and the man's T-shirt.

Watercolor wash

A simple watercolor wash on this dinosaur gives it life and really makes it stand out against a white background.

Applying watercolor as a wash

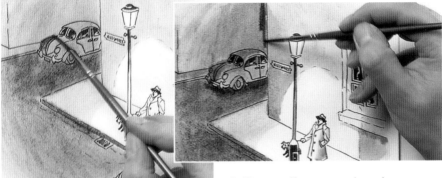

1. The line drawing must be in waterproof ink and completely dry before you start work. Wet the paper with clean water and introduce a pale gray wash.

2. Use smaller areas of wash to strengthen the shapes. When adding cast shadows, make them much deeper in tone.

3. Be sparing with tonal detail, as shown here by the figure under the light. It only needs a suggestion of shadow to show how the form curves away from the light source.

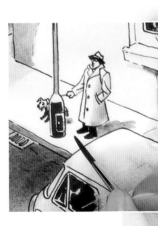

4. The gradual, wet-into-wet build-up of wash technique permits an extremely fine control of tone and texture.

ACRYLIC PAINT

Whereas traditional oil paints are rarely used to create cartoons (and need to be applied on special canvas paper on board, which is expensive), acrylic paints are much more convenient and, being water-based, eliminate the problem of waiting a long time for paint to dry. Acrylic is the newest of all the painting mediums and does have a lot of attractions for the cartoonist—when it dries it has a tough plastic surface which cannot be removed, but it can still be applied as a thin wash. Liquid acrylic can be used to achieve a watercolor-like effect. Chroma colors are another type of acrylic paints originally developed for coloring cartoon cells (cartoons painted on a clear plastic kind of sheet for photographing) used in animated cartoon movies.

Types of acrylic paint

Acrylic paint comes in tubes and pots, which need to be sealed carefully as alcohol-based acrylic paint dries very fast.

Squeeze carefully

Always squeeze tubes of acrylic paint very gently—otherwise you'll have blobs of paint flying everywhere, including onto your cartoon artwork and possibly household pets!

Uses of acrylic paint

- When dry, acrylic paints are completely waterproof.
- Acrylic paints dry rapidly.
- The dry acrylic paint surface is tough and resilient.

Transparent glazes of bright color laid over one another.

Opaque layers painted directly on top of dried color.

Paint mixed with an impasto medium can be used very thickly.

Dry-brush technique.

PAPERS

It is not essential to use high-grade paper for cartooning, but a firm, resilient surface helps to create a clean image and makes the original artwork more durable (plus, of course, it is much nicer to draw on). You should try as many different types of paper for your cartooning as possible and discover how various paper textures, finishes, and colors affect your cartoon drawing style. Remember that the paper must be thicker than normal to be suitable for any work you do using watercolor or gouache, otherwise it will cockle and wrinkle.

To do basic sketching and black line cartoons, size A4 white photocopying paper is quite adequate and you can buy this economically in packs of 500 sheets. Go for a minimum paper weight of 80gsm or preferably 100gsm. The weight refers to the thickness of the paper—the higher the number the thicker the paper. Cheaper papers will tend to feather the lines of fiber-tip pens. For your finished artwork it is always advisable to buy the best quality paper you can afford—ask to try out your pens on a test sheet first so you can see if the ink line stays crisp.

How big?

You will soon find that one particular size of paper suits you best—A4 or A5 are usually the most comfortable sizes to use. However, it is always worth trying out a larger size of paper (perhaps A3 or A2) and seeing how that affects your drawing style. Do bear in mind, however, that using larger sizes of paper makes it more difficult to post or scan your artwork.

Cartridge paper

Cartridge paper is good for sketches and brush-drawings and offers a heavy, resilient, and smooth surface.

Layout and tracing paper

Layout paper is semi-transparent white paper used for rough artwork, fiber-tip preliminary sketches, and color tests (but not for painting). You can work from one rough or layout to the next stage by tracing over.

Art boards

A popular type of art board is Bristol board, which is available in various thicknesses and is often used for illustration, graphic work, and cartoons; it is very smooth and takes ink beautifully, but is also expensive.

USING COMPUTERS

With the right software and computer accessories you can easily create all manner of exciting and vibrant cartoons without needing to use the conventional pen, pencil, and paper. The emergence of computer-generated cartoons has opened up a vast array of new creative possibilities for twenty-first century cartoonists.

Most PC operating systems include a program that will allow you to draw, paint, and edit images. You can draw an image directly onto the screen freehand, or else scan in an already drawn image. The computer program will allow you manipulate the size and shape of the image, to pick colors from a palette or create new "custom" colors, and combine visual images with type.

As you begin to discover the possibilities of drawing on-screen you will probably want to upgrade from a basic package to more sophisticated and specialized software. There is a wide choice available, although some programs, primarily aimed at professionals, can be very expensive. However, as these are continually being revised and improved, it is often possible to pick up older versions quite cheaply.

Changing the size

Once you have scanned your artwork in to the computer you can reduce the size to see how it will look when printed in a publication (where it will almost certainly be reduced). It is important to know how your artwork will look when reduced because fine detail may disappear or turn into black blobs. You need to know if this is likely to happen and redraw it, if needed.

Drawing freehand

One vital piece of equipment is a stylus and drawing tablet. Drawing with a mouse can be awkward and clumsy as it is held quite differently from a pencil or pen, whereas a stylus replicates the natural drawing movement, and you will find it easier to draw directly onto the screen. Tablets come in a range of sizes, with commensurate differences in price, but smaller ones are well within the budget of most artists.

Scanning: bitmap and vector images

If you scan a photograph, or a drawing of your own and then zoom in on an area, you will see the mosaic of colors, called pixels, that make up the image. Images made up from pixels are known as bitmap or raster images, and are the most common type for color work as they can create very subtle gradations of tone and hue. However, they do have one disadvantage: because each image contains a set number of pixels, they are what is known as resolution-dependent, which means that they will lose detail and appear ragged (pixelated) if they are enlarged too much or printed at a low resolution.

Bitmap or raster image at 100% and 400%.

Vector images, on the other hand, are resolution-independent, and can be enlarged as much as you like with no loss of definition. This is because they are made from curves, lines, or shapes that are defined by mathematical equations. Illustrator is a vector-based drawing programme. The shapes in Photoshop's shape menu, which allows you to incorporate lines, circles, rectangles, and so on into an image, are vector-based, as are the many variations of type, and any clip-art images you might like to import. Most software applications designed for painting and image-editing use bitmap images, but some of the graphics programs—usually titled Draw rather than Paint—support vector graphics.

Vector image at 100% and 400%.

Bézier curves use points and handles to adjust the shape of vector images.

COLORING ON A COMPUTER

Applying color to cartoon artwork can be done easily using a computer with software such as Photoshop, Illustrator, or Painter. While traditional methods of coloring cartoons by hand continue to be used by many cartoonists, the advantages of using computers with ever increasing sophisticated software is unleashing a new generation of hi-tech cartoonists.

THE ADVANTAGES

Applying watercolor, ink washes, and paint to original cartoon artwork always has the potential to become messy and mistakes can often occur. With computer software mistakes can be easily rectified on screen. A computer paint program can also emulate a vast range of traditional media including pen and ink, watercolor, fiber-tip pens, oils, gouache, charcoal, crayon, and lots more. The results are impossible to differentiate from hand-applied methods and can be as subtle as anything applied by hand. A computer never runs out of materials and once applied, color can be removed or altered in seconds with no waiting for wet surfaces to dry!

Using Photoshop

There are three ways to select colors in Photoshop: selecting from a standard or personalized grid (1), mixing colors using sliders (2), or picking from a rainbow color bar (3). It is also very easy to match a color in your work by clicking on the picker tool (4) then on the color you wish to match. The foreground and background boxes in the tool bar (5) used with the large color picker (6) give you control over areas of color. There is a range of standard brushes and drawing tools, and options for customizing them (7). The tool bar also has the usual digital equipment including selection, drawing, and cloning (8).

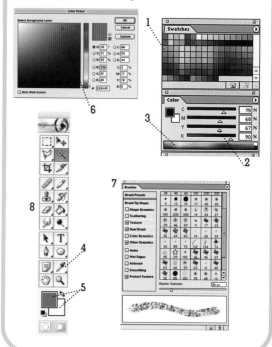

Using Illustrator

Illustrator offers color options for linear work and solid areas. Colors can be selected in three ways: by picking off a color grid (**1**), using sliders of the constituent colors (**2**), or selecting from a rainbow color bar (**3**). There are also options to specify the weight and fill of the line (**4**). The usual range of standard or customized brushes is available (**5**), as is digital equipment such as selection, drawing, distortion, and cloning (**6**).

Using Painter

Color options in Painter are more sophisticated than those in Illustrator and Photoshop. The color selector (**1**), allows you to choose tone with the central triangle, and control the hue with the outer colour wheel. Color can also be chosen with sliding bars (**2**), and tested in a sample window (**3**). You can match colours with the picker tool (**4**). Various drop-down menus (**5,6,7**), give you control over surface, drawing implement and the sharpness or texture of the implement.

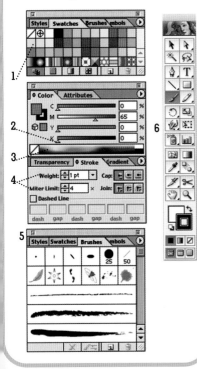

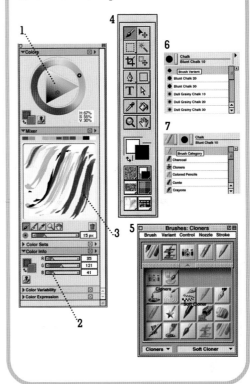

Using color

Any software designed specifically for drawing and painting provides a range of tools, from pens, pencils, pastels, and colored pencils to various different brushes. Painter, for example, has a vast range of brushes and drawing implements, enabling you to work in more or less any media you choose. Photoshop Elements only gives a choice between pencil, various shapes of brush, and airbrush, but it is possible to achieve many different effects by varying the opacity and pressure, and by working one color over another.

Choosing colors varies according to the program, but in most cases there is a palette or color wheel, and all you need to do is click on the chosen color. A useful tool in this context is the eyedropper, which allows you to precisely match an existing color. For example, if you want to repeat a color from one area to another, select the eyedropper tool and click on the color you want. This is also useful if you are copying a photograph and want to use the same colors to "translate" it into a colored drawing or painting.

When you are learning a new piece of software (which can take some time), the best course is to familiarize yourself with the brushes and other drawing implements by simply doodling. Digital drawing tools, especially those in the dry-media groups, don't always give quite the same effect as real-life ones, and you may find that you can achieve a more realistic colored pencil or pastel effect by using a different implement. This can be frustrating, but can also lead to exciting discoveries—you will enjoy this form of picture-making more if you regard it as a whole new approach with its own characteristics rather than trying to replicate the effects achieved with conventional materials.

(1) Painter Classic is a fairly basic program, but does have a good selection of drawing and painting implements, which can be modified by choosing different sizes and opacity values. The brushes used here are, from left to right, starting at the top: colored pencils, square chalks, waxy crayons, and leaky pen. Note that all the drawing and painting implements are referred to as brushes in the programs.

(2) Adobe Photoshop is primarily a photo-editing program, but a lot can be done with the basic brushes and pencils, and colors can be softened and blended by using the blur and sponge tools, or the eraser set at medium opacity. The examples here were made with a variety of brushes and pens, some from the calligraphic and square selection found under the Brushes menu.

(3) Painter offers a vast array of brushes divided into different categories. The three in the top row, charcoal, square chalk, and sharp chalk, are all from the dry media group, while the second row, dry bristle (here used with wet eraser), runny wash camel, and wet sponge, are found under the watercolor heading of the Brushes palette.

(4) A further selection of Painter's dry-media brushes, from left to right, starting at the top: charcoal in two layers, square chalk, sharp chalk, scratchboard tool, flattened pencil, and colored pencil. The scratchboard tool is an excellent drawing implement, and if you are using a pen and tablet rather than a mouse, the line can be varied simply by increasing or decreasing the pressure.

(5) The later versions of Painter, from 7 onward, offer a new category of liquid ink, which produces strong, rich colors and offers an exciting array of different brush variants, of which (from left to right) graphic camel, calligraphic flat, sparse camel, dry bristle, airbrush, and coarse camel are shown here. Liquid ink must be used on a layer of its own.

COMPARING MATERIALS

When you first begin drawing cartoons it is a good idea to extend your experience and experiment with a variety of drawing implements and materials. You may well find you do not like some; however, others you have never thought to try before may turn out to be perfect for your purposes. Although for almost all cartooning you will need to draw upon some kind of paper or card there is still great fun to be had by, for example, drawing onto colored paper with colored inks, pens, and paint—try everything and see what happens.

It is generally good to buy the best quality pens and papers that you are able to afford but it is more important to find materials that you enjoy working with and that enhance your work rather than to use expensive items that don't give you the freedom to get your work down on the paper as you want to. If you find that the cheap fiber-tip pens available at a nearby store are just right for your cartooning work then stick with them. Most art stores and suppliers will let you try out pens and paper before you buy so don't rush in and buy something just because it looks good and is highly priced. A cartoonist doesn't have to spend lots of money to be productive. Ideas, which cost you nothing to produce, are the most important asset you will ever have—much more valuable than any equipment!

Different approaches

As well as discovering the style and materials that suit you best, it is also worth considering the effect that different materials will have upon the mood and feel of your work. Each of these Cinderellas has been drawn using different materials, to emphasize different aspects.

Fiber-tip pens

Primary colors and a black outline mark out this Cinderella as being for young children. The medium suits the artistic style, which has elements of caricature about it. The message conveyed is immediate. Such a style is not as easy as it looks— the best way to start is to try doing a well-worked figure, and then simplify it.

Colored pencils

The artist has used colored pencils to create this romantic, realistic Cinderella. Colored pencils allow areas of light and shade to be created using the technique of hatching. This gives depth to the creation, and is a pleasing effect.

Pen and ink

This is a highly stylized Cinderella. Here pen and ink have been used to create a clean, crisp image but one without depth. Although it has not been explored here to its full extent, this is a medium that allows the artist to put in as much detail as he or she wants.

Watercolor

The translucent quality of watercolor allows the application of several layers, thereby creating tone. Watercolor is another medium that can be as loose or as tight as you wish.

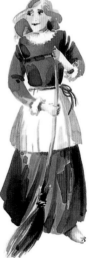

Brush and ink

Using brush and ink, the artist has given this form a rough, sketchy quality. The rendering appears haphazard and off-the-cuff, in part due to the chosen medium—though ink and wash can give a more controlled line. This is a loose, immediate style that would be most appropriate to a retelling that broke the traditional mold.

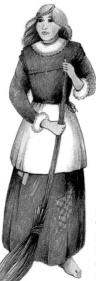

Stippling

The time-consuming technique of stippling has been used to create tone on this figure.

CHAPTER TWO

STARTING TO DRAW

SKETCHING FROM LIFE

Life is happening all around you—people are doing something all the time so get into the habit of doing as much sketching of them as you can. Small sketchpads are great for carrying around in your pocket and don't forget a pencil and pencil sharpener. Sketching real people may seem a little odd for a cartoonist but it is tremendously important to draw the human form and get to know all of its possible shapes from thin to fat, short to tall; how humans look when they are walking, swimming, and doing countless other activities. Constant sketching will sharpen your observational skills and make you really look at how the human form in particular operates. Animals, of course, also provide good material for sketching but can be much more challenging since they will not hold a pose for you so this encourages you to get marks down on paper rapidly! It is very useful when sketching to make notes alongside of colors for future reference.

Fast sketching

Your sketches should be done rapidly and spontaneously—don't try to capture too much detail, just get down enough to capture a brief impression of the people you have seen.

Sketchbook choices

A small sketchbook to carry in a bag or pocket will always be handy when wanted. Spiral-bound books are easier to open flat, but the ring binding does not allow you to extend sketches across two pages if required.

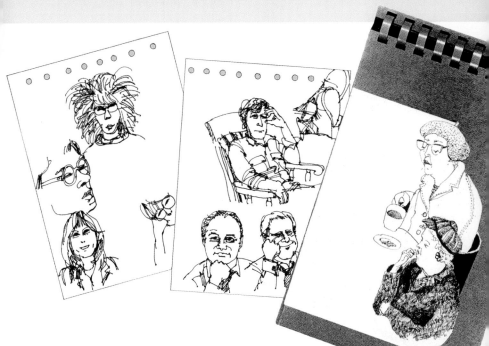

Sketch everywhere

Always try to carry a sketch pad and pencil with you everywhere so that you can make quick sketches of any interesting faces you might see. Producing sketches quickly will improve your drawing skills and sharpen your eye for getting down essential elements first—and this will help you to produce better cartoons.

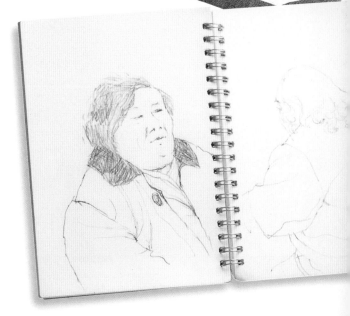

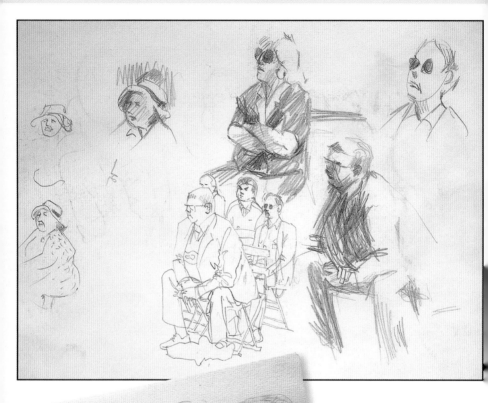

On location

It is not possible to finish every drawing on location, but there will always be another person, or the same one in a different pose. Record as much as you can, whenever you can.

Studies of movement

For fast-moving studies, concentrate on the largest forms and the dynamics of the pose, and glean the details from resting figures.

THE FACE

Drawing cartoon faces can be tremendous fun. Don't be afraid to experiment by exaggerating the features—really big noses, for example, immediately add humor and focus. Begin by drawing faces in pencil to loosen up your hand and get your lines flowing.

Humans as a species have eyes, noses, mouths, ears, and usually some hair on the top of their head—so what is it that makes us different from each other? The shape of the head and its proportions help to make us each distinct so exaggerate these in your cartoon faces.

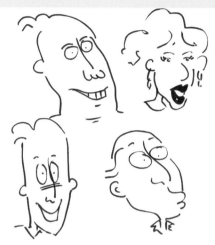

Expressive lines

Even with very simple linework, these heads convey a whole range of expressions and different characters. Hair can be drawn with only a few lines and by avoiding too much detail, you can create really simple but effective characters.

Character heads

All of these characters immediately tell us something about themselves or their profession. They are all drawn using cartoon conventions of dress and facial appearance to convey instantly who or what they are.

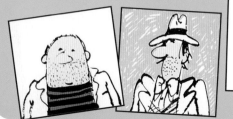

Block heads

It takes a while to master any new medium. Experiment with the line quality of your pencil, brush, or pen by drawing simple squares, circles, ovals, hearts, and triangles. Animate them with whatever eyes, nose, and mouth they ask for. See how much expression you can pack in with as few lines as possible.

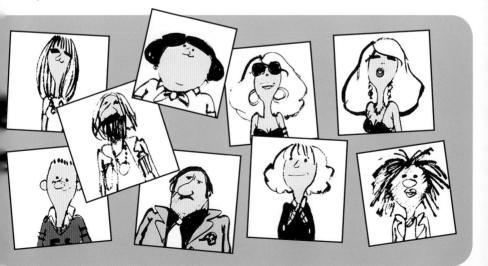

Stretch and squash

Cartoon characters are often shot into orbit, confronted by escaped monsters, or placed in some other extreme situations that requires extreme emotions. To get the most out of these situations, try imagining your character's head as a ball made of soft rubber, and allow it to stretch out or squash together and flatten out as needed. Don't be afraid to exaggerate—a lot!

Shapes
Simple shapes work best for heads. Making the mouth distort as well creates a really strong expression.

The mouth says it all
Lots of large teeth in cartoons make for great smiles or brilliant grimaces. Distort the shape and size of the cartoon mouth as much as you like to exaggerate the emotions.

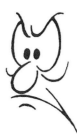

Eyes and mouth
Dots close together for eyes, combined with a downturned mouth, give an angry or annoyed cartoon face.

At a glance
The human face tells us a great deal about its owner—whether they are male or female, old or young, pretty or ugly, intelligent or stupid, fat or thin. Here is a selection of faces that are instantly recognizable from everyday life. You don't need to be told any more about these characters. The face alone says it all.

Eyebrow power
Eye dots with white spots and upturned eyebrows make for a happy cartoon expression.

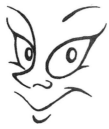

Raised eyebrow
A puzzled look is achieved by a raised eyebrow, together with the swiggly mouth.

Crafty look
Heavy lidded eyes, sloping eyebrows, and lines around the mouth create a crafty look.

Geeky
A pair of glasses always help when creating a geeky character. Add to this small dots for eyes and a toothy grin.

Goofy
Eyebrows high above the eyes and a toothy smile make for a goofy look.

PROFILES

While a front view of the face gives the cartoonist lots of opportunity to highlight features such as the nose, eyes, mouth, and hair, the profile also allows plenty of opportunity for exaggeration. A person looks very different in profile because we only see one side of the face. Some cartoonists use only the side profile in all their drawings and it works surprisingly well, rather like the ancient Egyptian paintings.

Happy birthday

One key to defining a character is to pinpoint his or her age accurately, with a minimum of trivial details. It doesn't take a mass of lines to make a face mature; it only takes a few—in the right places. See how this woman ages before your eyes.

Hair or no hair?

All of these profiles are exactly the same. The only difference is the hair. It is important to understand how one single detail like hair style can dramatically change a character's whole appearance.

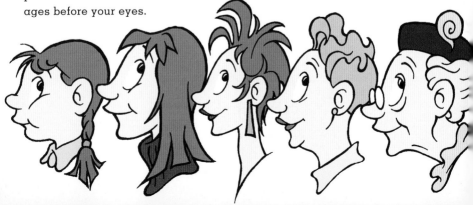

Female profile

The profile of this woman can be altered drastically depending on the style of hair she is given. Adding accessories such as dress collars, jewelry, and eyelashes also changes a character. Try it yourself and see how different you can make a single character appear, just by changing a few details.

EXPRESS YOURSELF!

The point of a cartoon is often made through facial expression. You cannot afford to let the viewer miss the point, so your depiction of this inner feeling needs lots of exaggeration to be effective and funny. In many gag cartoons you must also make it clear who is doing the talking—a well-drawn open speaking mouth is essential in your cartoon repertoire.

You also need to be able to depict any emotion needed, such as anger or happiness. This involves a combination of effective facial features, especially eyebrows. Get the expression right and your cartoon character will really come to life.

Facial expressions

Facial expressions are important in cartooning, and you are the best model in this case. Stand in front of a mirror and contort your face. This will help you to capture fear, anger, puzzlement. But in cartooning general perceptions can rule, no matter how unrealistic they are. For example, the man opposite is scared—his hair is standing on end!

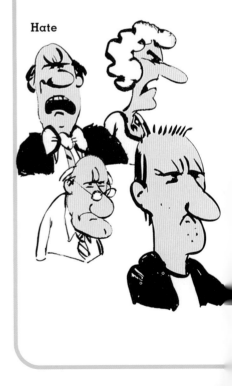

Hate

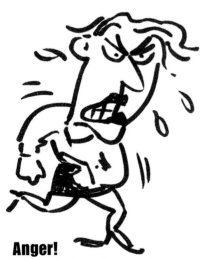

Anger!

Sweat beads and action lines, combined with facial features of gritted teeth and down-sloping eyebrows help to make this woman appear very angry.

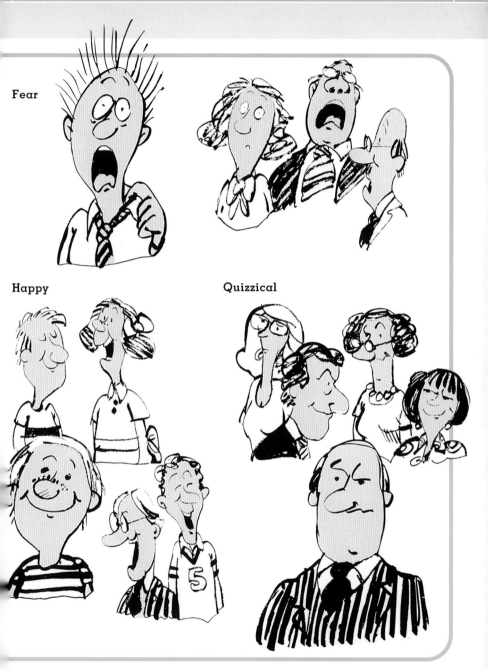

Fear

Happy

Quizzical

STICK FIGURES

Using the stick figure method of constructing cartoon characters simplifies the process of drawing the body and is a good place to start. Like everything else in cartooning you'll need to practice a lot and learn to exaggerate and distort the proportions of the body. Acquiring an understanding of the human skeletal and muscular structure is certainly useful to any artist, including cartoonists—it is worth studying a few books on the subject because once you know the rules you can then break them with confidence in your cartoon drawings.

LESS IS MORE

A cartoon only needs to give the viewer enough clues for them to understand what is going on in the scene. You don't need to produce highly technically correct drawings for the humor to be understood. This applies equally to cartoon bodies—draw just enough clues and the viewer's imagination will provide the rest!

Try elongating bodies, making them wider, or stretching them. Look at the examples shown here and see how much you can simplify body shapes to create a really humorous appearance.

Stick figures are easy

Start with a simple stick figure in the pose you want and add clothes and a face. Complete the figure by adding hands, feet, and other details.

Get the pose you want

You can add muscles to your stick figure, making them an Olympic athlete, or else just draw an average guy.

DRAWING FIGURES

Just by looking around us, we can see a great diversity of shapes and sizes—all of which we cartoonists can caricature. Notice, for example, how the difference between male and female in cartooning terms is accentuated by broad hips, shapely legs, and upper torsos. Cartoon superheroes have large torsos to make them look impressive but you do not have to follow the usual look—you could for instance create a non-muscular superhero with a very thin body! Cartoon heads can be huge in relation to the body—it gives you the chance to show really large features for indicating emotions.

1 ➔ **2** ➔

Step by step

Here are the typical steps for drawing a full-figure cartoon. Start with a line for the spine, add circles for the joints, and draw ovals for the heads, hands, and feet. Add two more ovals for the hips and torso and a couple more for fingers. Then start fleshing out the form, leaving the details for last.

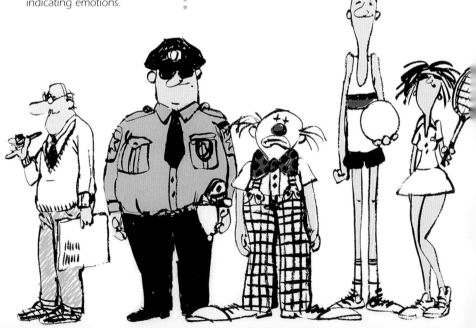

3

4

Shape up!

Give your characters odd and memorable shapes by exaggerating their body sizes.

Stereotypes

Each of these characters is a stereotype—from the overweight policeman to the glamorous beauty contestant. Although they shouldn't be over-used, stereotypes are a great aid to cartoonists because they are recognisable and convey a lot of information to the viewer very quickly.

Heavyweight

A soft, pear-shaped body and short, squatty legs give this round-edged giant an ungainly quality. Notice that the little patch of ground creates a setting and anchors him to the page.

Speed demon

The action line is angled and the character's arms, legs, and hair all stretch out wildly. Speed lines and little clouds of dust make it clear that she's really burning up the asphalt.

Drama queen

Head thrown back
and hips thrown
forward, this character
strikes a dramatic pose.
She is standing still, but her
figure is very much alive, thanks
to the action line making a roller coaster curve
through her figure. Add a wild-eyed expression and arms
all aflutter to increase the dramatic gesture. Remember,
overacting is a good thing in a cartoon character!

HANDS AND FEET

Hands and feet in cartoon figures can be a great source of fun and can really make a character amusing. The best advice with drawing hands and feet is to keep it simple. Don't bother trying to get them anatomically correct. Keep it bold and impulsive and draw with confidence. Study how other cartoonists depict hands and feet in their work. Look at the techniques that you think work and those that don't; how are hands drawn when waving, making a fist, or holding a cup for instance?

One of the first things you will notice about hands in cartoons is that they are not very lifelike—for example, very often they only have three fingers. This is because in the early days of cartoon animation movies the artists found that by drawing only three fingers they saved time and it looked less cluttered on the big screen. It's a peculiarity taken from the cinematic format but not all cartoonists use this approach and if you feel happiest drawing the full complement of fingers then that's fine.

Cartoon hands do not need details such as fingernails unless it is essential to the character—a femme fatale could be shown with long fingernails, for example. It will, however, help you to observe and make sketches of people using their hands when they are talking, gesticulating when angry, or playing a sport perhaps.

Hands up!

By keeping it simple and spontaneous you can give your cartoon characters really effective hands. Forget about anatomical accuracy! Look at this example to see how simply-drawn hands and fingers add to the fun of cartoon characters.

Expressions of character

Hands are very expressive of character, and are always of prime interest to the artist. If you look at the selection here, you will see how much they can vary, sometimes bearing little relation to the hands we know in real life.

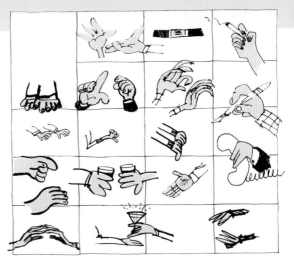

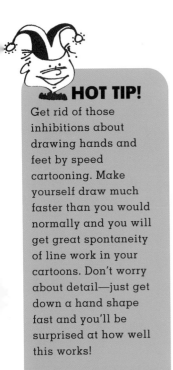

HOT TIP!

Get rid of those inhibitions about drawing hands and feet by speed cartooning. Make yourself draw much faster than you would normally and you will get great spontaneity of line work in your cartoons. Don't worry about detail—just get down a hand shape fast and you'll be surprised at how well this works!

Stand by your feet

Feet are a very important part of the human body. Notice how the heel bulges out behind the line of the back of the leg. Also note how people can stand with their feet at an angle, like a clock saying ten to two. The legs will be wider apart if the character is fat, and parallel if the character is seated. Remember, too, that footwear can pin down a character as easily as a hairstyle.

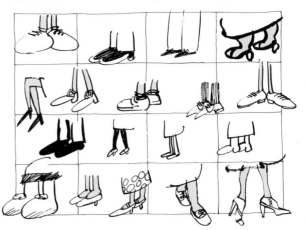

DON'T HESITATE, EXAGGERATE!

The marvelous thing about being a cartoonist is being able to distort and exaggerate to create humorous characters. The world that the cartoonist creates on a piece of paper come entirely from the imagination with no rules as to what is right or wrong! Once you realize what a tremendous amount of freedom this allows then you can really enjoy being the master of your own cartoon world.

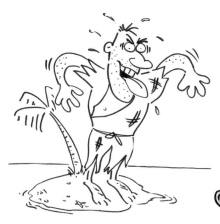

Get away, castaway!

Making the castaway larger than the island is an example of how exaggeration can be used to create a new and different scenario.

Bodily transformations

Distortion and simplification are the cartoonist's bywords for creativity. Every cartoon that you draw is a tiny melodrama that you populate with unique characters.

Surprised?

Huge eyes and the word "Yow!" really do exaggerate this character's surprise.

Cat alert

The simple construction of this cat and the lively zig-zag fur pattern make for a great cartoon character. The exaggerated human features increase the fun.

CHILDREN

Cute and sweet or little monsters—the cartoonist can have lots of fun drawing children. Facial features such as eyes can be exaggeratedly large while noses can be small—it's a case of mix and match.

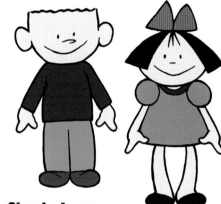

Simple faces

Cartoonists can really simplify the depiction of children with just two dots for eyes, a line for a nose, and a longer line for the mouth.

Profile

Details of the face in profile can also be reduced to just a few lines to show an eye, an ear, mouth, and hair.

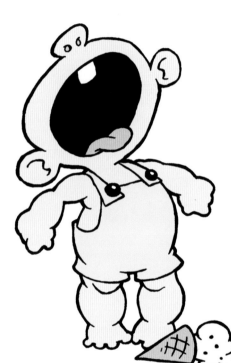

The scream

The classic cartoon baby scream is really just a black hole with one upper tooth and a tongue coming out over the bottom lip.

Big head

The cartoon heads of children can be much larger than the body. Note also the extra detail of eyelashes on this girl's face.

Cute and easy

Black dots or ovals for eyes are good for babies along with the brief curve of a line for the nose and similar for the mouth. This is a cute cartoon baby.

Fruit head

The young child's head is basically pear-shaped with an ear stuck on the side. Freckles and other details can be added just for fun!

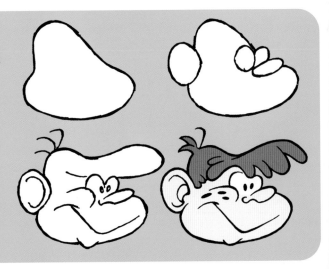

GROWING OLDER

The human figure changes dramatically with the passage from babyhood to adulthood, the most noticeable difference being in the relative proportions of head and body. In middle and old age people alter in shape rather than proportion, either accumulating fat and spreading in certain areas, or becoming stringy and skinny. The posture typically becomes more hunched, and flesh begins to sag, producing pouches and wrinkles.

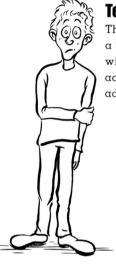

Teenager

The plump child has become a thin, uncertain young man, with typical sloppy dress, ackward posture, and adolescent spots.

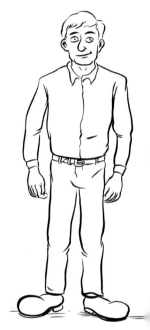

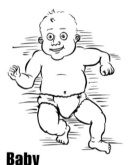

Baby

The nappy proclaims this figure to be a baby, but equally so does its large head and rounded limbs.

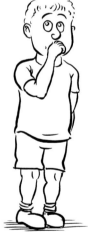

Child

The head is still large in proportion to the body, but more revealing are the posture and clothing—thumb in mouth and shorts.

Adult

A reasonably fit, muscular, and broad-shouldered adult male, confident and ready to face the world.

Middle age

Ten years later, the smile is still hopeful and the expression alert, but the beer-belly has become quite pronounced.

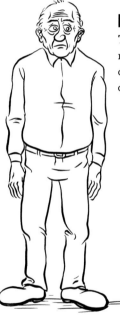

Late middle age

The face and figure are now beginning their drooping descent into old age.

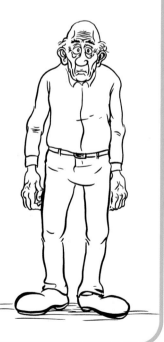

Old age

The body has shrunk, making the feet and hands appear unnaturally large, and the head is no longer carried upright.

TRICKS OF THE TRADE

Among all the basic information that it is necessary to put into a cartoon, you will often also need to include hints of movement suggesting what has just happened and what is about to happen. This can be done in many different ways. There are a host of "tricks of the trade" you can use that will quickly add a touch of professionalism to your work and create easy-to-read action and movement in your cartoons.

When you want to make your cartoon characters appear to move then you'll find action lines very useful. They add visual impact and help give life to your cartoons, acting as a kind of illusion to make your static cartoon contain indicated movement.

Sweat beads are another very handy device in cartoons, and you can even turn a dry cartoon scene into a rainy one by the mere addition of some lines and bouncing raindrop shapes! A person knocked senseless or drunk can be indicated by floating star shapes around their head. These conventions for indicating various movements and states are visually accepted and understood all over the world—although try not to overuse these devices or they can detract from the essential elements of the cartoon.

States of mind

A character's state of mind is easily shown by something happening around its head— you can use symbols to make the thought process visual and visible.

Adding motion

The waiter on the left is drawn without any action lines while the waiter on the right demonstrates how effectively action lines can be used to bring a cartoon to life.

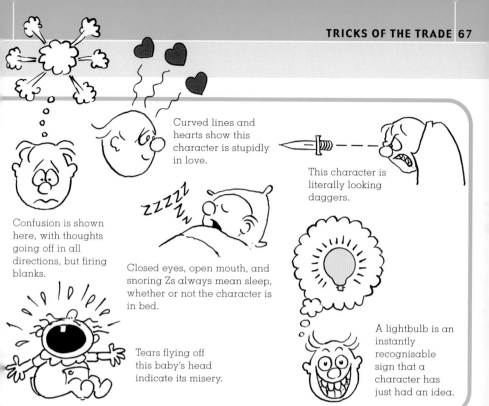

Curved lines and hearts show this character is stupidly in love.

This character is literally looking daggers.

Confusion is shown here, with thoughts going off in all directions, but firing blanks.

Closed eyes, open mouth, and snoring Zs always mean sleep, whether or not the character is in bed.

Tears flying off this baby's head indicate its misery.

A lightbulb is an instantly recognisable sign that a character has just had an idea.

Liven up your characters!
This character would be quite static without the action lines that make him appear to be jumping for joy.

Raindrops
Make it rain on your character by adding just a few lines!

Suggesting movement

In addition to the action shown in poses and gestures, movement is most usually and easily shown with linear devices, long or short, straight or curved.

Wobble lines are drawn parallel to the wobbling object—vary the line lengths to fit the shape.

"Smoke rings" diminish in scale to show the distance being covered—smaller equals further away.

Directional lines make the overall flight pattern of a running character.

Broken line puts movement into solid shapes.

Move it!

A turning head with multiple eyes is a great trick for suggesting rapid movement, while a character with sweat beads, action lines, and a raised foot suggests very active laughter.

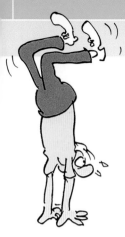

Precarious position

The angle of the body indicates this is unlikely to be the perfect handstand.

The zigzag outline suggests shock waves running through the body.

Biff, baff!

Fights offer lots of opportunities to use exaggerated facial expressions and action lines. Notice the use in these cartoons of a flying star and sweat beads to add impact.

Alarming

The fear and alarm of this character is shown by the lost shoe, the terror of the bulging eyes, the clawed hands, and the hair standing on end.

Sounds

Cartoons use lots of visual equivalents for sounds. Think about the quality of the sound and what kind of line or shape can interpret it.

This chick is still learning and its song is shrill and jagged.

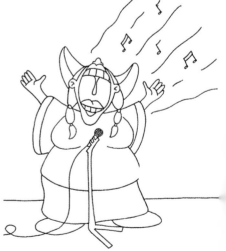

A one-note whistle swells out in a cloud of air—give it some momentum with speed lines.

Curving lines are "sweet" and music has its own symbols.

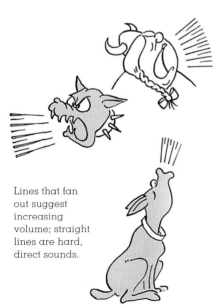

Lines that fan out suggest increasing volume; straight lines are hard, direct sounds.

Floating musical notes alongside wavy lines emanating from this opera singer are excellent cartoon devices for creating a sound effect.

Drunks and drunkenness

Drunkenness has a whole range of devices relating to the person's physical state and actions. Start with the overall body language, like this drunk's free but unsteady movement.

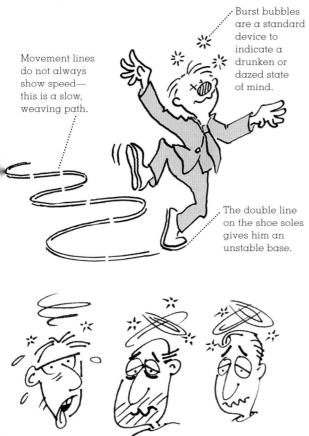

Burst bubbles are a standard device to indicate a drunken or dazed state of mind.

Movement lines do not always show speed— this is a slow, weaving path.

The double line on the shoe soles gives him an unstable base.

Three ways to show drunkenness. Notice the use of two swirling rings round the top of the heads with accompanying stars and the dopey eye look, slanted eyebrows, and wavy mouth. Putting a tongue hanging out of the mouth adds another extra dimension of drunkenness.

Mood devices

A swirling line above the head can indicate someone who has been knocked out or hit by something and is feeling dazed.

Create a mood of depression with a black scrawl of lines above the head. Lines under the eyes and a crooked line for the eyebrows add to the gloom.

CLOTHING

Remember that in cartoons you are communicating visually. Your audience should be able to understand your character's personality without having to read a word. Certain articles of clothing can be very effective as instant visual clues—some have endured for such a long time that they have become clichés to indicate a profession or status; for instance, a scientist's white lab coat, a spy's trench coat, a burglar's striped T-shirt. In cartoons the clothes are vital clues for the viewer as to who the characters are and where the scenario is placed.

Clothing is everything

How you clothe your characters defines to a great extent how the viewer perceives them. Play with different costumes and try unexpected combinations.

Fashion gone wrong
This style victim has it all wrong—the clothes don't fit and his shirt is creased and stained. Clumsy shoes complete a picture of fashion disorientation.

Summarizing character

Clothing is essential to building your characters but often just a single prop can summarize a character. Many of these will seem almost too obvious. But the reader has to take in the situation in a split second, so all the signs must be very clear.

Comfortable and casual

This character's comfortable clothes are suggested by smoothly drawn lines. The pattern on the trousers is inessential but livens up the drawing.

Heroine

This Supergirl lookalike has the basics right—color co-ordinated, and pants outside her tights—but is she really steady enough on those heels to save the world?

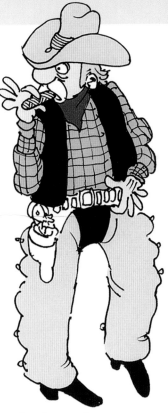

Shapeless

Whatever shape this lady has is lost in her sturdy coat, given one continuous all-round curve by the plaid pattern.

Cowboy style

An traditional old-time cowboy typically wears a checked shirt and baggy, rumpled chaps.

Teen angst

The baseball cap and cell phone are recognizable accessories to a basic teenage dress code.

STEREOTYPING

Cartoons are full of stock characters and stereotypes that instantly tell the viewer exactly who they are. There are borderline stereotyping areas, where something that makes one person laugh could seem offensive to another. But, in general, stereotypes are good, reliable material for cartoonists.

Stereotypes are easily understood even though they usually bear no relation to reality. The archetypal cartoon prisoner wearing a suit covered in arrows is a shorthand image that everyone understands—it is visual symbolism established over generations of cartoonists.

Uniforms are very useful for stereotyping because they identify without personalizing. You as a cartoonist have to decide just where to draw the line. Settings can be equally stereotypical—the desert island with the single palm tree is an iconic cartoon stock image. The bristling cacti that symbolize the Old Wild West is another mainstay perpetually employed by cartoonists.

Space girl
While including all the necessary costume and context for a spaceman stereotype, this image also plays with convention: a young black female is substituted for an older white male.

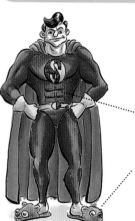

Superhero
The superhero genre stereotypes male bodies, but is easy to satirize.

The exaggerated musculature is lightly rendered.

Generic costume and cape are juxtaposed with "girly" pink slippers.

Wild West
The cowboy is identified by the Stetson hat, boots, and lasso, as well as by the background.

Any male face could be substituted here without disturbing the stereotype.

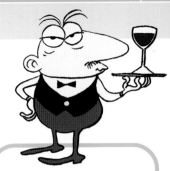

The clothes make the cartoon

A character's clothing defines who they are. Certain costumes and items of clothing are so familiar that they have become stereotypes in themselves. Always remember, though, that some old stereotypes may have gone out of fashion now, to the point where they will not be recognizable to your audience.

Unusual influences

The design of comic characters can be influenced by many unlikely things, including abstract art. Why not put both eyes on the same side of the head? Have the nose face east and the toes face west. Feel free to be as wacky as you want to be.

Obnoxious tourist

This guy's Hawaiian shirt, baggy Bermuda shorts, plus colossal feet in beach sandals instantly pegs him as a stereotypical tourist.

Rough wrestler

The figure of the wrestler, like the superhero, is also a stereotypical male body.

Stubble and shades equal "bad" attitude.

The wrestler cuts a rough, hairy, menacing figure.

The vinyl disc clinches the now outdated stereotype.

The wrestler's costume rarely covers more than a small part of his body.

Rock DJ

The stereotypical DJ: note the importance of clothing styles, which vary according to the musical genre and soon date.

ANIMALS

Animal physiques vary enormously, from long-legged giraffes to plump pigs. However, a few tips and principles for drawing cartoon four-legged animals will help you to tackle any creature you want to draw. If you have a pet dog or other animal then now's your chance to use them as an ideal model for your cartoons. Watch how your pets walk, run, lie down, jump, stretch, and what antics they get up to. This is all invaluable information to a cartoonist especially when you come to include animals in your work.

Pert and alert

One way to draw a four-legged cartoon beast is to start with a line drawing of a four-legged table (1). Draw a kidney bean shape around the tabletop for the body and a circular head (2). Add tubular legs and some further details (3). The finished dog seems to be standing solidly on the ground (4).

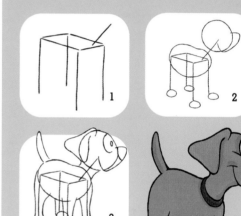

Sit, table, sit

Beginning with the table shape, try thinking of the table legs as rubber hoses or wires, which you can bend to create any pose you want. Then just cover the tabletop with a body shape, and add a neck and head.

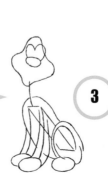
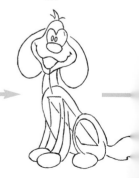

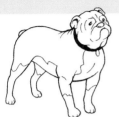

The bulldog is sturdy and muscular with a large head and broad body.

From sketch to finished cartoon

To turn an animal into a cartoon, study the real thing and do a few sketches of it. Look out for standout characteristics. For example, a bulldog has a barrel chest and an enormous jaw. Emphasize these features. Exaggerate and simplify. In spite of their formidable appearance, bulldogs are very sweet-natured.

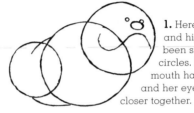

1. Here the head, chest, and hips of the dog have been simplified into three circles. Her prominent mouth has been enlarged and her eyes have moved closer together.

2. By adding powerful, slightly bowed legs, big clumsy feet, a short ear, and some wrinkles, character begins to show through.

3. The completed bulldog deliberately lacks the menacing look that cartoonists usually bestow upon the breed. Here, characteristic wrinkles add to the dog's warm appearance.

HOT TIP!

Keep it simple! Use straight and curved lines and dots for eyes when drawing a cartoon dog's face. Ears are good for creating expressions too.

Get them moving!

Once you have mastered the basics, you need to learn how to add movement to your cartoon animals. Start by looking at how real animals move, paying particular attention to how their legs work. For example, a dog's front legs bend in a similar way to human arms, but their back legs are a whole other matter. Always start your drawing with the animal's backbone (action line) and then flesh out the initial stick figure from there.

This kangaroo is realistically proportioned, but with some areas rounded and exaggerated. Clues such as the ears flapping back show the direction of movement.

This horse's face and feet are comically outsized. The body proportions have been made plumper and cuter than those of a real horse, but the realistic leg construction suggest natural and authentic movement.

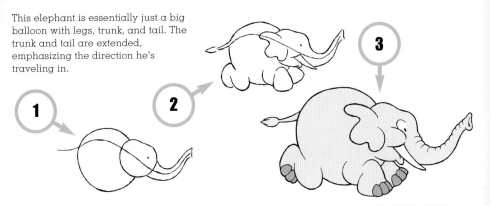

This elephant is essentially just a big balloon with legs, trunk, and tail. The trunk and tail are extended, emphasizing the direction he's traveling in.

Slippery characters

Animals such as turtles, snakes, and fish don't necessarily make as warm or cuddly a character as a furry mammal. However, you can play up their more exotic body contructions to create eccentric and interesting characters.

Realistic fangs contrast with a droll smile on this serpent. Snakes make interesting characters because their bodies have such flexibility of movement, allowing them to coil, writhe, and curl around all kinds of objects.

The realistic elements of this fish have been exaggerated to create a more distinctive character. Notice the goggle eyes and fat lips.

ANTHROPOMORPHISM

Anthropomorphism means giving human attributes to things that are not human. It can apply to inanimate objects that are given human features such as arms and legs, or to animals. This is a wonderful excuse for cartoonists to really go wild with their imagination and create all kinds of life forms where none existed before!

Often anthropomorphism depicts animals standing upright just like humans with two legs and two arms, although of course we know they have four legs in real life. Spectacles can be placed on animals, as can clothing and shoes.

Simplification

If you have trouble drawing an animal face, take a simple basic face and draw around it the animal's most dominant feature, such as the lion's mane or the cat's whiskers.

Almost human!

As cartoonists, we love to humanize our animal friends. The most common tricks are having the animals walk on two legs, and putting them in human clothes as seen here.

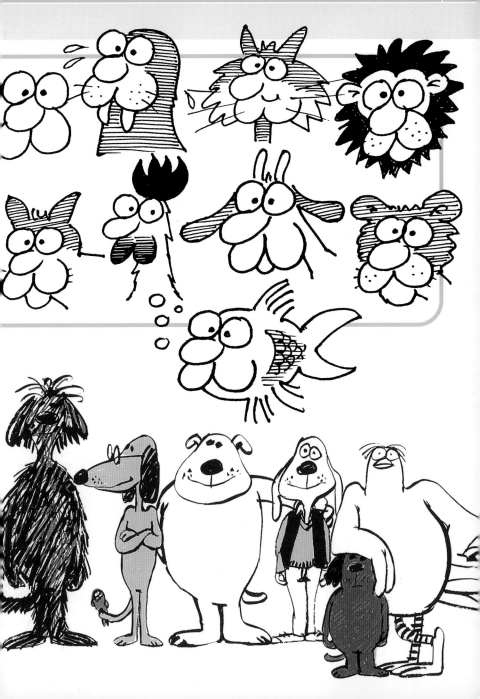

Human into animal

Just as an animal can assume human form or characteristics, a few extra touches can turn a human into any animal you choose.

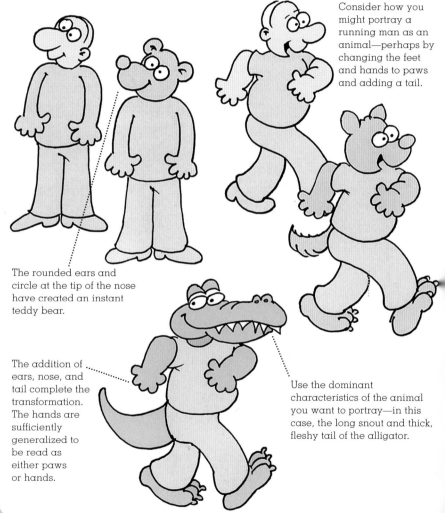

Consider how you might portray a running man as an animal—perhaps by changing the feet and hands to paws and adding a tail.

The rounded ears and circle at the tip of the nose have created an instant teddy bear.

The addition of ears, nose, and tail complete the transformation. The hands are sufficiently generalized to be read as either paws or hands.

Use the dominant characteristics of the animal you want to portray—in this case, the long snout and thick, fleshy tail of the alligator.

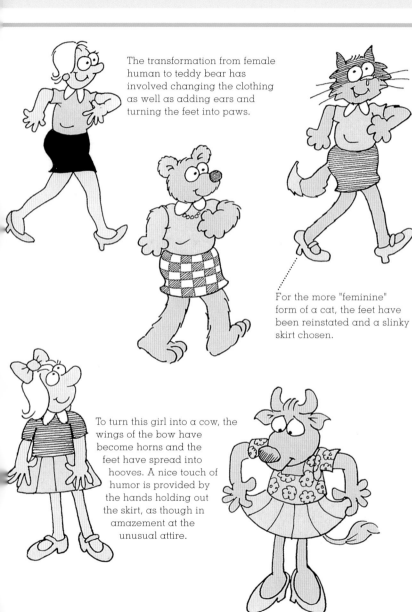

The transformation from female human to teddy bear has involved changing the clothing as well as adding ears and turning the feet into paws.

For the more "feminine" form of a cat, the feet have been reinstated and a slinky skirt chosen.

To turn this girl into a cow, the wings of the bow have become horns and the feet have spread into hooves. A nice touch of humor is provided by the hands holding out the skirt, as though in amazement at the unusual attire.

Appliances with attitude

Everyday domestic appliances can all be
brought to life simply by adding a pair of eyes
and a mouth. A whole individual character can
be created with just a few lines.

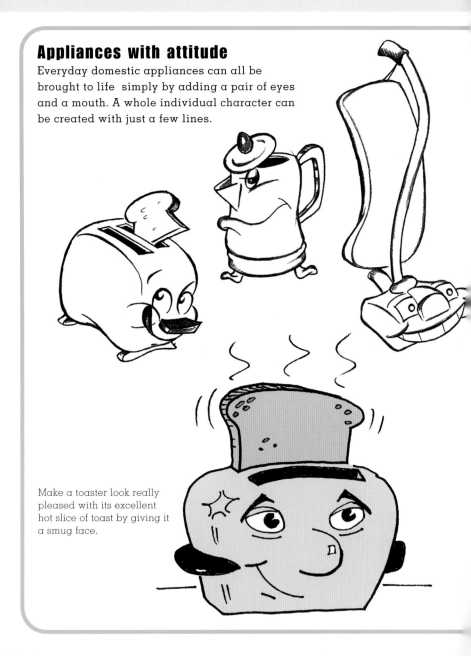

Make a toaster look really
pleased with its excellent
hot slice of toast by giving it
a smug face.

Food for thought

Make an ice-cream cornet come to life and look so good it eats itself!

Flying friends

Planes are perfect for cute cartoon characters especially since once you have put eyes and a mouth onto them the wings and landing wheels look like arms and legs.

BACKGROUNDS

The purpose of a background in a cartoon is to show your readers when or where your characters are. Graphically, this means drawing the surfaces that surround a figure or figures in order to convey all the information necessary to help the reader locate the cartoon.

Flat marker tones differentiate the elements of the panorama.

A silhouette can be painted in with Indian ink over pen line.

Time and place

A city skyline can be rendered as line or silhouette according to how dark your image needs to be. Ask yourself: is it day or night?

Making choices

When drawing a landscape you must decide what your cartoon requires. Do you need to show a specific place or a generic scene?

Building a background

The background not only needs to place your characters but should also complement them. Treat the background as if it were built from the figure outward, gradually shaping it around your character/s.

Show that your horizontal ground is not empty. Make it an environment: break the horizontal with a vertical line.

Earth-color washes for the interior background convey grime.

Stereotypes

Backgrounds can also use established stereotypes. This background provides the setting for urban angst and decay.

Blank canvas

This generic coastline works as a familiar, but unassuming, background against which to place your characters.

Ground the floating figure on a horizontal surface. A simple horizon line is enough.

Distinguish the environment —turn it into a location. Use pictorial details and props to define time and place as precisely, or as vaguely, as necessary.

Dramatize the drawing. Render areas of black or graduated tone to add weight, solidity, depth, or mood.

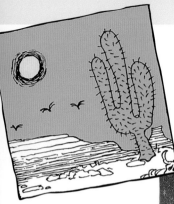

Classic setting

The classic desert landscape is shown here, complete with cactus, vultures, and burning sun.

Working over the line drawing with colored pencils allows the color to carry atmosphere.

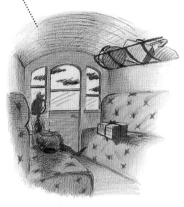

Space

This iconic background is the setting for well-known images and motifs—in this case, of space exploration and space fantasy.

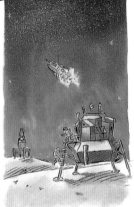

Conveying mood

The size of the carriage, its exaggerated perspectives, and non-naturalistic colors all spell menace for the solitary little girl.

Autumnal gold, brown, and purple are applied in thick pencil strokes.

Seasonal variations

A few small details in a background can indicate a particular time or season.

Familiar background

This generic suburban street scene contains both typical and stereotypical elements.

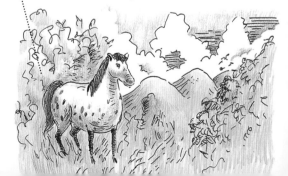

Background props

General background props also give a cartoon instant placement. These can be picked up from other cartoonists, but it is always best to go back and study the real thing for yourself before attempting to draw it.

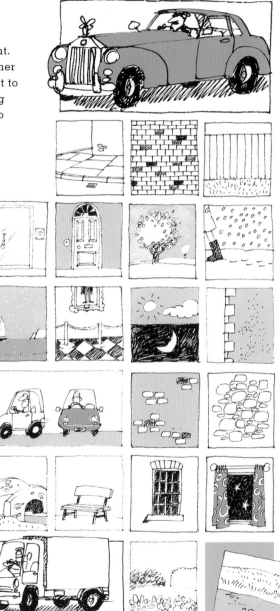

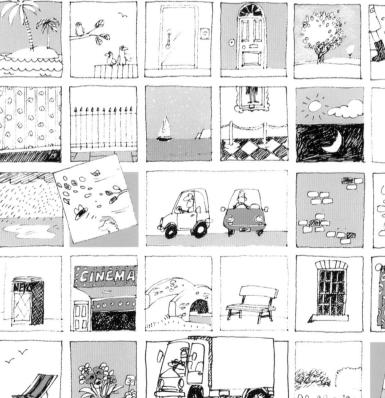

COLOR

Color is one of the best ways to add impact to your cartoon. However, it is always more expensive to print in color so try not to use color when none is required. If you have the option of color, you should ask yourself whether it is merely decoration or is it a vital element of the image.

COLOR IN PRINT

Spot or second color in a cartoon is just one color added to black and white that enlivens or adds drama—it is often employed in comic books.

The publisher usually determines the color. A full-color printing process, on the other hand, works by overprinting four colors—magenta, cyan, yellow, and black—as a series of minute dots that combine to give a full range of colors.

There are many ways to get from a piece of finished artwork to a printed color copy of your cartoon. None of them should affect how you invent your gags but each can influence the kind of artwork you produce and the way that you draw it.

Monochrome printing

Printing in a single color—usually black—is called monochrome printing. Most newspapers and magazines contain monochrome sections that include cartoons. For these, you can draw line artwork, line and wash, or use percentage tints.

Two or three colors

Printing two or three colors usually involves printing black plus one or two extra colors.

Spot colors

You can choose spot colors from the extensive ranges of inks available as solid colors.

Four colors

In the four-color process, you produce full-color artwork, which is separated electronically into an image made of cyan, magenta, yellow, and black dots.

Color adds clarity

Here, objects are differentiated by the various distinct colors used.

The natural fade of the sky is reversed to heighten the contrast with the tree.

Clothing colors and shading stick to a limited range of red, blue, and gray.

A red/green complementary contrast increases focus on the face.

Using white

Local color is used sparingly in the image. By leaving the background white, attention is focused on what is essential for a gag.

Unusual coloring

Here, the envious green is inserted in a picture otherwise colored quite naturalistically, emphasizing the "storyline."

Making a point

A comment on unhealthy lifestyle—the man's grayed coloring shows that a diet of burgers is doing him no good at all.

Bright-colored, dripping relishes are based in reality but over-lush.

The red tongue makes a horrid, greedy focal point in the gray face.

LETTERING AND BALLOONS

The caption under a cartoon (if it needs one—some cartoons use no words and rely on the purely visual joke) is usually set separately by the printer/publisher so all you need to do as the cartoonist is to write it legibly using a light blue pencil (this will not be reproduced when the cartoon is printed). However, some cartoonists do put their lettering in speech balloons as part of the actual cartoon. You may want to use lettering in your cartoon, particularly in a comic strip and so you will need to develop your lettering skills for it to be effective and look professional. Alternatively, you could utilize computer software to generate consistent lettering on your cartoon.

Balloons

Lettering containing dialogue and thought is usually separated from a cartoon's picture area by enclosure in a white space with a linear border: the word balloon. The speech or thought balloon's tail points from the center of the balloon to the mouth of the character.

I'LL NEVER DO WHAT YOU WANT ME TO-- NOT IN A MILLION YEARS!

I'LL NEVER DO WHAT YOU WANT ME TO-- NOT IN A MILLION YEARS...

I'LL NEVER DO WHAT YOU WANT ME TO-- NOT IN A MILLION YEARS!

I'LL NEVER DO WHAT YOU WANT ME TO-- NOT IN A MILLION YEARS!

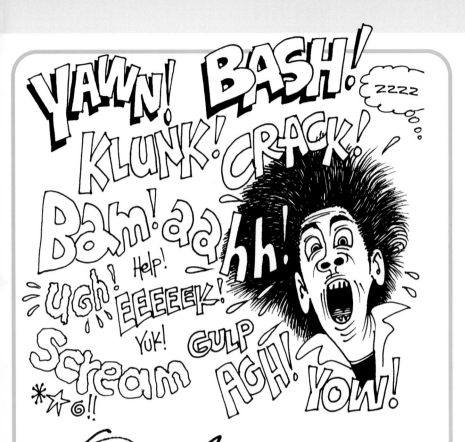

Sound-effect lettering

Sound-effect lettering does not have to obey the strict graphic rules that govern words inside balloons and captions. Feel free to use any type that suits your cartoon.

COMPOSITION

Composition is all about how you arrange the characters, settings, and various props in a cartoon. This is an important consideration because it will determine how successful your cartoon is in terms of it being instantly understandable and funny. The length of time a person takes to scan a cartoon with their eyes is less than a second and the viewer will spend perhaps only a few seconds trying to understand what is happening in the cartoon, so you have to ensure your composition makes the cartoon's point straight away. If the viewer has to struggle to understand the cartoon in any way then it has failed in its objective.

Bear minimum

This cartoon of a bear tells the viewer at a glance all they need to know about the scene. The grumpy expression of the bear and his position halfway up a tree in a forest can be understood immediately.

The cartoonist has managed to convey a lot of information with the minimum of lines or detail. The background forest consists of a few wavy lines while the tree the bear is climbing is simply drawn. Even the bear, of which we can only see the head and four legs, is very cleanly rendered. The viewer's imagination does the work of translating these few visual clues into locating the scenario and what is happening.

Setting the scene

Look at this cartoon scene of a man and a room. Without a caption he could be read as the woman's husband, a salesman, or a friend. In this composition there are lots of background props such as the TV set, cup and saucer, books, an infant, a dog, furniture, a picture on the wall, and even the wallpaper design. He could have just entered the room or else be about to leave—only a caption will tell us which, and hopefully the gag as well. Compare this to the cartoon of the bear in the tree above and you will appreciate the difference in drawing styles—but both work very well because they are well thought out compositions that give all the information the viewer needs to understand the locations.

Remember the viewer always looks

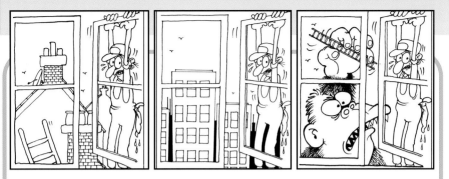

The background story

In these three cartoons, the changing composition gradually alters the point of the gag. In the first, the window cleaner is in a bad enough position, having lost control of his ladder. The background detail looks like residential houses, suggesting he is two or three floors up. In the second cartoon, the change of background to the simply drawn but unmistakable blocks of high-rise buildings makes his predicament appear all the worse. Finally, the "background" becomes a second character in the cartoon, giving the scene a completely different context. The way the huge ape brandishes the tiny ladder revises the viewer's sense of scale. Without seeing the background buildings, we can't assess how far the man is from the ground, but that is no longer an important feature of the storyline.

at the cartoon first then reads the gag line second, if there is one. After reading the gag line the viewer may then return to look again at the cartoon just to consolidate their understanding of the gag.

CREATING FOCUS

In cartoons we use various devices to help focus the viewer's attention on certain areas where emphasis is needed to heighten the humor or raise tension. There are many ways you can direct your viewer to the focal point of the cartoon. A thicker line quality, a splash of color, a dramatic tonal contrast are all useful effects to achieve focusing on a specific area of the cartoon.

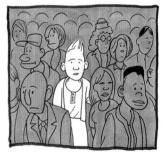

Monochrome focus

Use of a gray wash around the central figure is extremely effective at focusing the eye on the figure in a crowd.

Method of focusing

A clever use of composition and color makes the woman in this cartoon the focal point. The two dogs, one on a level with her head and the other looking up to her from over the fence, lead the eye to the woman. The gradual alteration of the sky tone also helps to highlight the central figure. The line work is bold and simple enabling the whole scenario to be understood very quickly.

Focusing devices

Use a bold line. Not only does the dog fill more of the visual field than the man, the thick contrasting lines of its face and forepaws, and the foreshortening of its figure, bring the dog into focus.

The visual field is divided into simple areas of black and white related by the direction of hatching. This converges on the crystal ball, emphasized by the direction of the background figure's gaze.

The videotape is a solid black area within a white area, which is, in turn, within another solid black. In the white area, the gaze of the figures combines with these divisions to signal the tape's importance.

You can focus your reader's eye using color contrasts with great richness and complexity. Here, contrast moves focus between the bright, warm colors of the figure in the doorway and the second figure.

FORESHORTENING

Foreshortening is an exaggerated perspective effect that can be applied to figures and objects. Its value in cartooning is that it can add a dynamic quality—making objects and characters seem to leap out at you from the page. It is a technique often used in comic strips where action and movement is necessary.

Distortion

Bear in mind that cartoons are not architectural renderings. Once you understand perspective, you can use the rules to make something believably three-dimensional and then distort reality for effect. The principles of perspective can then be applied to people, animals, and curvy objects through foreshortening.

Foreshortening the figure

This follows the basic principle of near/large and far/small. This is easier if you break down the shapes into basic building blocks of spheres, ovoids, cylinders, and cubes.

The hand held up in anger is a set of curved cylinders and ovoids. To draw the cartoon version, start with a close-up of the hand and draw back, showing smaller proportions, to give a 3-D effect.

When you are foreshortening the child's figure, start with a very large sphere for the head. Even without foreshortening, children's heads and faces are drawn proportionally larger than adults'.

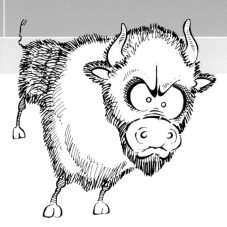

Making the back end of this bossy buffalo smaller than his chest and further enlarging his face brings him nose to nose with the viewer.

The lines of this cottage have been curved into a friendly face.

Exaggerating his body position and drastically enlarging his left foot help this character to jump off the page.

Drama

You can use foreshortening to accentuate the drama of cartoons, by stressing the depth of a picture. The foreground character's foreshortened arm runs through several depths of picture, combining the division between foreground and background with focusing devices.

PERSPECTIVE

Perspective can be used in a simple or complex way to add visual impact to a cartoon. If your cartoon characters are not shown in any context—just as isolated figures or a head-to-head arrangement—then you do not need to worry about perspective, but as soon as you introduce an implied background space or situation, the viewer subconsciously expects it to conform to basic rules of perspective because as humans we have been taught to read spatial information in this way. Total distortion of space is of course valid in a cartoon if it is part of the concept you have imagined.

One-point perspective

Draw a horizon line—representing your eye level—and fix a vanishing point on it. The further the point is to one side, the more objects on that side are compressed. Vertical planes that face you are drawn flat-on and undistorted. Lines can then be drawn back from corners and edges to the vanishing point to create the sides of a cubic shape that recedes directly away from you. In a solid shape you see the underside if the object is above the horizon line, the top plane if the object is below. But you can also treat them as hollow forms. Make construction lines in pencil, then ink in the appropriate shapes.

Points of view

Here, the same cartoon has been drawn from different points of view. The change of view changes the shape of the picture and also changes where the viewer's sympathies lie.

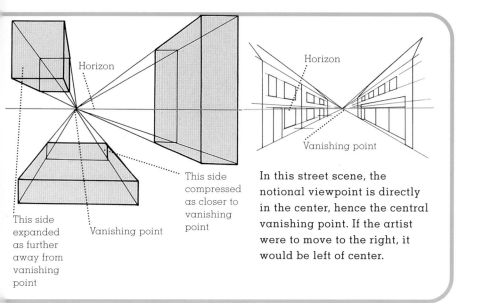

Horizon

This side expanded as further away from vanishing point

Vanishing point

This side compressed as closer to vanishing point

Horizon

Vanishing point

In this street scene, the notional viewpoint is directly in the center, hence the central vanishing point. If the artist were to move to the right, it would be left of center.

Unusual perspective

The first cartoon (above) uses normal perspective but you may wish to try an unusual viewpoint and perspective to add drama. In the second cartoon (right), the ground level viewpoint adds impact to the desk and the man sitting behind it. This view is sometimes referred to as the "devil's eyeview" because it is very melodramatic.

CHAPTER THREE

TYPES OF CARTOON

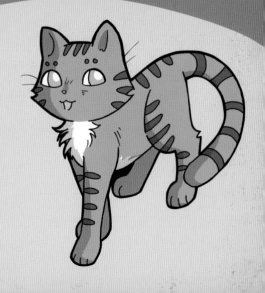

THE SINGLE-PANEL CARTOON

A single-panel cartoon is literally a cartoon in just one panel, either with or without a gag-line. It is designed to fit into a small oblong space or panel in a magazine or newspaper. This kind of cartoon is very popular and can be drawn in any style and deal with almost any subject. To specialize in producing these cartoons you need to be able to originate fresh ideas and gag-lines on a regular basis, and will also need to a good understanding of grammar and the ability to pare your ideas down to get the maximum impact. Readers will spend only two or three seconds looking at a cartoon and reading a gag-line before moving on, so the single-panel cartoon has to make its point almost instantaneously.

Single-panel cartoons will often utilize cliché and familiar domestic or work situations such as relationships between husbands and wives, parents and children, lovers, and bosses and employees. Stereotypical locations and situations are recycled continually, for example the desert island, the office desk and secretary, or the boardroom of a company with assembled executives. These cliché situations and locations are an endless source of amusing gag-lines for cartoonists and can be constantly reworked and made topical. Viewers are comfortable with these familiar cartoon locations and situations and are ready and willing to be amused—all you have to do as the cartoonist is to provide this receptive "audience" with a wry smile, a silent laugh, or (if your cartoon is really good) then a good belly laugh!

"Start worrying at high tide."

Clichés

The desert island scenario is one of the great all-time cliché settings used by cartoonists. Here we see two castaways—one looks like a new arrival while the other has been in situ for some time (his beard indicates this) and his laconic advice is made darkly humorous by the encircling sharks. Notice that this cartoon cannot work without the gag-line and the gag-line likewise needs the cartoon.

Instant placement

Cartoons should provide visual shorthand, giving just enough information and clues so that the viewer knows instantly what and where the cartoon setting is. In this cartoon, just a few visual clues (deck rails, lifebuoy, man in captain's uniform) tell us that the setting is the deck of a ship, without the need to draw in any more detail.

"Tell me Captain, which side is port and which is gin?"

"Cloning, not CLOWNING!'

Puns

This cartoon relies upon similar sounding words with totally different meanings being confused, as well as a touch of the absurd. Word play can often be particularly effective in single-panel cartoons.

Exaggerating the familiar

In this situation, notice that the gag-line is not the man in the shower talking—it is a kind of third person observation on the scene. However, the cartoon could work equally well without a gag-line or caption. The humor comes from the universal experience of taking a shower where the temperature control is difficult to regulate. Also notice the exaggerated scale of the shower unit—it's huge! Don't be afraid to exaggerate lettering or distort scale in a cartoon to get the joke across to the viewer—it all adds to the humor! Precisely because this is a cartoon the viewer will accept the scale distortions.

Taking a shower calls for a big decision.

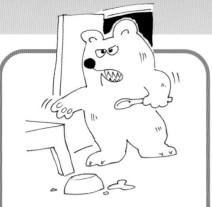

"Get forensic in here now—I want the porridge thief apprehended fast!"

Using familiar stories

This cartoon is a modern take on a traditional nursery rhyme—another effective way to generate fresh humorous ideas. The bear's demand for modern police tactics to arrest the villain completely turns the old nursery rhyme on its head.

Recognizable situations

Hotel bedrooms are another great setting for cartoons. The dilemma posed here is quite bizarre and the humor is heightened by the viewer being able to see what the woman cannot. It uses large lettering to label items and plenty of sweat beads and action lines to focus attention on the man. Note that this cartoon could work without the caption.

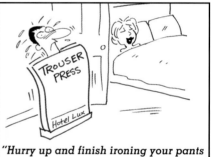

"Hurry up and finish ironing your pants and come to bed dear..."

"Well dear, the pesticide's got rid of the aphids from the garden."

Making the familiar absurd

The innocent comment of the man coming into the house from the garden is made humorous by what he cannot see just behind the door. The humor in this cartoon is based upon absurdity, another great weapon for the cartoonist. The size of the aphids is greatly exaggerated, and the situation is made ridiculous by having them assume the human attitude of sitting comfortably on the sofa.

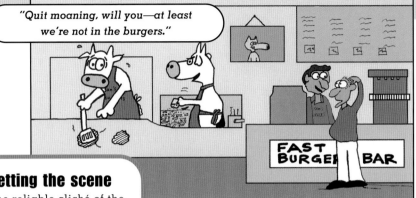

Setting the scene

The reliable cliché of the psychiatrist's office can provide endless ideas, as can transposing animals into human situations. Notice how few clues are needed to let the viewer know where the chicken is located—the stereotypical cartoon psychiatrist, complete with bow tie and glasses, and the obligatory couch are more than enough to set the scene.

"But why? Why did I cross the road?"

Takeaway humor

Fast food and takeaways provide plenty of ideas for cartoonists. In this cartoon the flat blocks of color (added on the computer) give a lively feel to the scene.

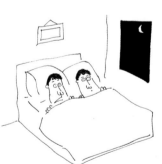

"Ever woken up in the middle of the night and imagined there's your exact double in bed beside you...?"

Surreal touches

This cartoon is a good example of dark humor. The joke is not so much funny as unnerving and perhaps surreal, although nothing about the scenario is weird in itself.

THE CAPTIONLESS CARTOON

The captionless cartoon can be either single- or multi-panel but almost always relies upon the visual image to make the joke rather than a caption or gag-line—although it may sometimes include within the cartoon words on signs or notices that are essential to the gag. This kind of cartoon is difficult to create and for that reason cartoonists who can consistantly produce good captionless cartoons are fairly rare. The captionless cartoon has to be understood by the viewer quite quickly in order to work effectively. One of the world's best and most prolific cartoonists in this specialized area is Sergio Aragonés, whose work is often populated with many characters.

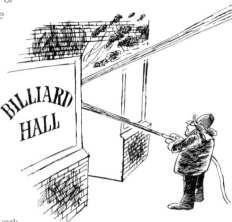

Visual puns

A clever visual pun from the Dutch artist Wessum. In this cartoon the viewer is expected to make the connection between the sign and the water deflection to realize the joke.

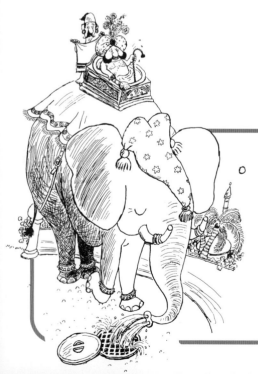

Hidden joke

The elephant is a long standing favorite for many cartoonists and this meticulously drawn cartoon by Hoffnung is all the more enjoyable because we are compelled to study it closely before realizing the brilliant joke element it contains.

Global humor

Egyptian cartoonist Hassan Moustafa demonstrates the universal nature of humor without using a single word in this family scenario cartoon. The joke element of this cartoon is for the viewer to find and then to use their imagination to supply mental images of what happens next.

HOT TIP!

The subject of human vanity and a man's desperate effort to impress a woman is a scenario that most people will be able to relate to. Being able to recall similar situations and thus identify with the cartoon is what makes the cartoon funny. Embarrassing situations are great material for cartoonists—simply turn them into a cartoon scenario!

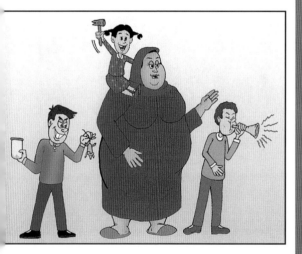

Using text within the cartoon

Using words on placards and T-shirts are useful techniques in captionless cartoons. The humor in this cartoon (right) relies on the inappropriate message on the man's T-shirt.

Signs in shops, notices, and written information are all fertile sources of gags for cartoonists. In this cartoon (left) the joke relies upon a familiar situation experienced by anyone browsing the magazine shelves in a store. Try to think up variations on this scenario to create new cartoons.

Cynical humor

A very common scene of a street beggar is here given a cynical twist by showing him blatantly saying why he is in need of money—not to help himself but to continue funding his alcoholism. This kind of cartoon is designed to shock and may even reinforce prejudices. It would be more likely to be found in satirical magazines rather than in more mainstream media.

Placing items out of context

Good old Santa Claus is an ideal stock figure for cartoons. Here the idea of grocery store checkouts combines neatly with the stocking hung up for Santa to fill with presents.

Taking signs out of their usual environment and placing them in a totally unexpected scene can often result in amusing scenarios.

Out of place

Take a skateboard and a lazy young skateboarder, put them on a running machine in a health club and you've got a cartoon. Try to bring together disparate things or characters in your cartoons—it requires a bit of "off the wall" thinking but it can result in some amusing cartoon ideas.

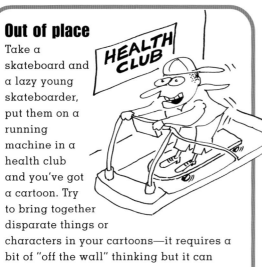

HOT TIP!

Thinking up ideas for captionless cartoons does require a very original approach. To get started, look at some captionless cartoons and then with each one try to come up with a new sign or location or different characters to create a new, original cartoon. You may find it difficult at first but be persistent and you'll find that ideas will form. Do this on a regular basis and you will find in time that your mind will sharpen up and you'll cultivate much more of an awareness of amusing situations that can be turned into cartoons. What you are really doing is exercising that part of your creative brain, and with regular exercise you'll make it fitter and the cartoon ideas will flow—try it and see!

THE POLITICAL CARTOON

A political cartoon polarizes support or criticism depending upon who or what is the subject of the joke. They usually deal with a current or very topical event, which means the cartoonist has to create them very quickly to catch the mood of the moment. For this reason political cartoons have a very short shelf life—once the controversial subject has become yesterday's news then the cartoon is no longer relevant or interesting. Like all cartoons it is a disposable item once used and seen. However, cartoons can make very strong statements on a political subject often by

Personification

A political cartoon commenting on the rising cost of education, this uses the device of personifying the huge fees that students are made to pay for their education to make its point. This type of cartoon has no room for subtlety in getting its idea across to the viewer.

The newly graduated student is about to be hit by a Big Bill for his university education.

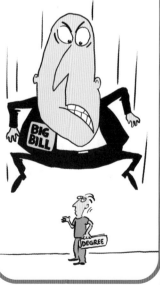

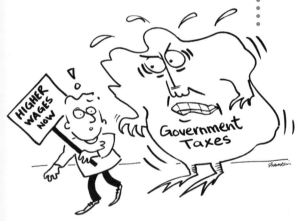

Global themes

The political content of this cartoon could be relevant to many governments in many different countries. Resentment against government taxes and workers' demands for increased wages are a fairly constant feature. Making a monster of a political policy is an effective metaphor and is widely used by cartoonists.

simplifying a complex situation between individuals or countries and have more impact than the printed word—the old adage that a picture is worth a thousand words can be true when a great political cartoon appears in the media. Cartoons in this genre can also be used as political propaganda.

To be a successful political cartoonist you need the ability to grasp and understand a whole range of political issues, sometimes at very short notice, and then produce a cartoon that relates directly to the elements of controversy with acerbic wit. Political cartoons can be very powerful and often provoke outrage—the genre is very widely seen in America and Europe.

"Which credit card would you like— the 6%, 18%, or 34% annual interest?"

A surprising twist

Crime is a subject that the cartoonist can depict with wry humor to make a social and political point—in this case, a common mugging scenario is turned on its head by having the victim surprize his attacker with a totally inappropriate question.

Social commentary

Older people participating in activities that were once the preserve of the young is an increasingly common sight and a political and social topic of discussion. This cartoon highlights the issue with wry humor and there are many other areas where older people could be put in amusing situations by the cartoonist.

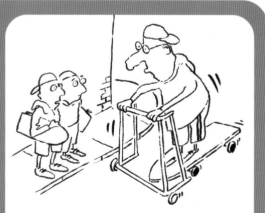

"He's the oldest skateboarder in town."

CARTOONING FOR ANIMATION

To animate is to bring something to life—in this case, cartoon characters. Cartoon animation has been transformed due to the power of the computer, with movies such as Toy Story and Finding Nemo proving incredibly popular and attracting new audiences to the classic genre. Not all cartoon animation has to be at such hi-tech levels, however—simple animation of cartoon characters is also possible and within reach of the amateur cartoonist at home via a PC and some easily available software.

There are two traditional basic methods to animation: the first is called "straight-ahead," which is creating a sequence of growth or movement. The second method is "pose planning," in which the animator draws the extremes of an action and then adds in-between drawings to smooth the total action.

Here is a range of traditional animated cartoon characters. Notice the large amount of distortion in the figures, such as short legs, large heads, and the general stereotyping for easy-to-recognize characters.

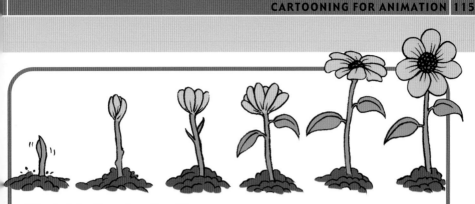

Straight-ahead animation

To practice straight-ahead animation, start with a simple object, such as a flower. Then place a piece of tracing paper over the initial cartoon drawing and redraw the flower in the same position, only slightly taller and fuller. Continue this process, making the flower taller and fuller as you progress. This cycle can take as few as five or six drawings—or as many as you wish, depending on the size of the flower. To see how your drawings will look in "animated" form, cut out the individual drawings after drawing them on thin card and place them in order to make a "flip-book" and when you flip the pages you will see your flower "animated" and appear to open.

Flip-book

A flip-book is an easy and fun method of creating your own animated drawings. Hold the flip-book in one hand and then with your other hand flip through the sheets quickly but separately as shown (right) to see animation in its most basic form.

Pose-planning animation

Pose-planning animation involves using extremes and in-betweens to take a character from one gesture to another. The extreme poses are planned first, and then the in-betweens are sketched in to connect the extremes. In the example shown opposite, a puppy is attracted to a butterfly and starts with extreme pose **(1)** and ends with extreme pose **(4)** with just two in-between sketches **(2-3)**. The more in-between drawings, the smoother and more natural the overall movement will appear in animation.

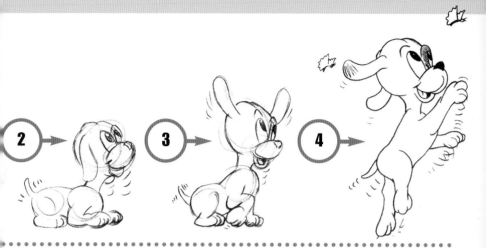

USING COMPUTERS

Computers have made the traditional process of animation much more efficient and faster, with software to create 3D (three dimensional) animated films now available for home computer use. This has enabled the amateur home cartoonist to produce animation sequences to a high professional standard. Besides using 3D animation software for movie making it can also be excellent for generating artwork for 2D cartoons and comic strips because it enables perspective (buildings or objects in particular) to be quickly generated with any viewpoint, and then printed out and traced for the comic strip. It also allows the cartoonist to create backgrounds with astonishing variation and detail.

There are many processes involved in the making of an animation, depending on how complex and subtle the finished result is planned to be. If working in this genre is your aim, then it is best to try to get a job in the actual animation industry and learn from the bottom just what skills are involved and required. Artistic skills need to be allied to a knowledge of the technical production side and of course the ability to work as part of a team, since all modern major animations call for a wide range of specialized skills to bring them to fruition.

Computer animation

A striking example of cartoon animation created by using a computer. Notice the incredible background detail and lifelike rendering for surfaces.

MANGA

The tremendous surge in popularity of manga comics in recent years has spawned a whole new generation of comic strip artists who are adopting the unique manga drawing style. Originating from Japan, "manga" refers to comics or cartoons drawn in a specific style. Most young Japanese fans of the genre use the term "anime" meaning animation because the comic strips are drawn with a great sense of movement. Over 40% of all light entertainment magazines and books published in Japan are in the manga style and read by people of all ages and social standing. Western cultures are increasingly not only enjoying manga but also adopting it as a cartoon style.

The advent of the digital age has made a huge difference to manga with home computers enabling (with the right software) virtually anyone to produce professional-quality artwork for this genre of cartooning.

STYLIZATION IN MANGA

Stylization is probably the most significant recurring element of manga artwork. The characters are drawn with stylish and sharp linework. In manga there is much less text than in traditional Western style comics and manga artists put greater emphasis upon facial expressions to convey emotions rather than use words. Eyes are often drawn much larger than usual and with highlights around them to indicate emotive states of mind. The use of onomatopoeia, or written sound effects to represent noises, is also common in manga.

Visual shorthand in manga

Visual shorthand is used to tell readers what they need to know about a character's emotions—without the need for exposition, explanatory text panels, or dialog.

Sparkles
Extreme happiness
in romantic situation

Ghost leaving nose
Dead

Vertical lines
Shocked

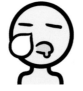

Bubble from nose
Sleeping

Mushroom cloud
Sigh of relief

Pounding vein
Angry

Teenagers

These are a couple of manga teen characters.
Notice the characteristic large manga eyes
and the mascot. It is common for characters
to have mascots or creatures that can talk.

Spiral/helix
Dizzy

Chick on head
Innocence

Scribble cloud
Very angry

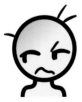

Hair bristling
Annoyance, irritation

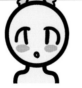

Hearts
Romance, in love

Beads of sweat
Embarassment,
nerves, discomfort

**Bubbles above
head**
Drunk

Typical features of the shoujo style are large eyes with sparkling highlights and the economical use of linework—for instance, notice the few lines drawn for the nose and mouth.

Shoujo

Shoujo is the Japanese word for "girl." Shoujo manga refers to comics produced in Japan specifically for girls to read. It has a style of comic artwork designed to appeal to female readers and the comics are almost exclusively written and drawn by women, with stories focusing strongly on relationships and romance as well as emotional struggles and complex, mature plots.

Shounen

Shounen is the Japanese word for "boy." Shounen manga are comics intended specifically for boys, although the audience has now widened to include both sexes. The central characters are always boys and the accent is on action and movement with some kind of conflict involved. "Speed lines" or "action lines" are frequently used.

Robots

Giant robots are a popular recurring theme in shounen manga, often representing great power granted to a young male character.

COMIC EFFECTS IN MANGA

However dramatic the action or emotional the scenes might be in a manga story, humor remains a key ingredient of the genre. Early manga had a strong comic focus, and it has evolved to contain ever more outrageous ways of presenting humor. One of the ways it does this is through exaggeration of the style of the manga used to illustrate funny situations without relying on dialog. This method is called "hyperstylization"—it enables an emotional state to be portrayed in an amusing and entertaining way.

Non-human characters

In manga, non-human characters and animals tend to react to the lead characters' emotions and sometimes reflect the reader's feelings, so that the reader feels they are watching the action alongside the non-human character. Animals also act as protective guardians, giving the main character strength or supernatural powers.

Hyperstylization

Zombie gaze

This exaggerated gaze emphasizes the character's emotional state. The mouth extending beyond the bottom of the face gives the impression that the mouth is open much wider than it ought to be.

Wobbling limbs

Giving characters' arms and legs an almost jelly-like quality creates the impression of a character dancing or moving in a daze, with a blank and blissful expression, oblivious to what others think of them.

Floating cheeks

This character's cheeks are drawn so that they appear to hover away from the skin—an exaggeration indicating a moment of extreme happiness.

Simple body

Reducing the shape of the limbs to a simple point makes the character look simple and cute, though also ridiculous.

CREATING MANGA ARTWORK DIGITALLY

Much of manga artwork is created with the use of a computer, using software such as Adobe Photoshop or Corel Painter. To create manga in this way calls for an artist being skilled in all aspects of cartoon creation, from initial pencil sketches to inking, coloring, lettering, and special effects.

Some manga artists draw directly onto the computer using a drawing "tablet" and stylus, later manipulating it using sophisticated software programs to produce finished artwork. However, depending on which software and hardware you buy, it can be relatively expensive to set up. Before doing this it might be wise to try drawing manga with just the traditional tools of the cartoonist to get a real "feel" for the genre— and then transfer your artwork to the computer later by scanning it in. It is important to get a good scanned image to ensure that you make your pencil lines of a consistent darkness without any smudging.

From concept to completion

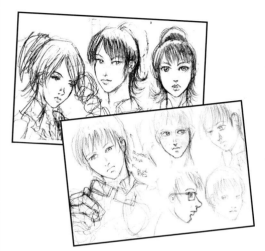

1. When you've conceived your story, sketch out character designs (above) so that you begin with a feel for what they will look like. With short stories, it is less important to develop these designs, as characters will only make a brief appearance, but with larger stories more detailed designs are necessary.

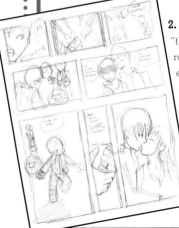

2. Sketch out the pages as "thumbnails" with very rough artwork. These can easily be changed and adjusted until the story flows nicely, before you produce final ink versions.

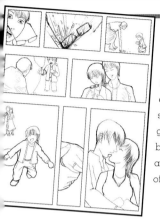

3. After drawing out neat line art in pencils, apply your inks. In this example, the speech bubbles are going to be added by computer, so the artist has left them off the original lines.

4. A combination of flat, gray tones and pattern tones have been used to add shade and definition to the artwork. Speech bubbles have been added, paying attention to the original sketches for their placement. The page is now finished, and ready to go to print.

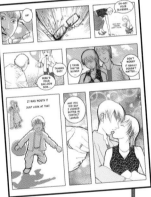

5. The final printed version, printed in Sweatdrop Studios' anthology *Love, Sweat, & Tears*. You can see it here with another page from the comic, working as part of the whole.

WEB MANGA COMICS

Comics no longer need to be printed on paper—they can instead be displayed on a website. The Internet is a wonderful means of exposure for comic artists, both amateur and professional. The international popularity of manga-style comics, combined with the convenience of reading comics online, has allowed even beginners to gain a global audience for their artwork. The advantage of going online is that it will cost you virtually nothing, and you will get quicker and more immediate feedback from readers of your comics to help you improve—although you must be prepared to accept criticism.

COMIC STRIPS

Comic strips essentially tell a story, which may be humorous, serious, romantic, fantasy and horror, or educational and instructive. Traditionally found in newspapers, some comic strips have proved to have great longevity and remain popular with succeeding new generations of readers—for example, Peanuts by Schultz has enjoyed a global audience for many years.

When creating a comic strip, you are inventing an entire world from your imagination. Drawing comic strips demands lots of different skills and the ability to constantly keep the strip going with fresh plots and story lines. You as the cartoonist need to know all of your characters intimately because unless they come alive for you they will not come alive for the readers. You have to totally believe in your characters and know everything about them in order to devise a successful comic strip.

There are two basic formats of the comic strip; one is the continuity strip (an ongoing adventure over a period of time), while the other is a stand-alone strip that tells a gag or a complete story each time it appears. To draw a continuity strip, you will need to be able to write consistantly good scripts and generate new ideas all the time to maintain the continuity, which can be very demanding if your strip runs every day. Even a weekly strip can be time consuming, with the pressure on all the time for completed artwork and new gags or story lines. Study a range of comic strips that appear regularly and try to analyze the jokes or how the pace of an ongoing adventure is varied, and how the cartoonist draws different scenarios and keeps the strip fresh and interesting.

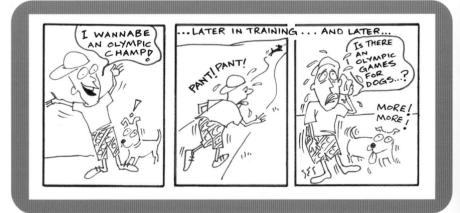

Topical comic strips

This is a topical cartoon strip, drawn during the Olympic Games. The humor is derived from the would-be athlete failing miserably in running against his pet dog. Notice the simple background details and devices such as sweat beads.

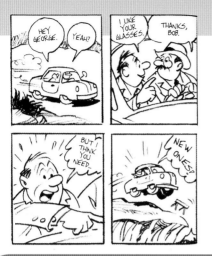

Frame by frame

This is a rough layout for a four-frame strip. It runs almost like a movie scene. The first frame locates the action with two characters in a car, the second frame moves in closer to the two characters in dialog, the third frame introduces emotion moving in even closer to focus on the reactions of just one character, and the final frame wraps up the action and delivers the punch line.

The breakdown

Whether you have just two panels or many pages to fill with your strip, the first stage in its construction is the rough breakdown. Some cartoonists pencil out "thumbnail" sketches at a fraction of the finished artwork's size, while others compose their sequences at the same size that their finished art will be. Either way the aim is the same: taking a scripted or visualized continuous sequence, you literally break it down into the picture, word balloon viewpoints, or sound effect shapes that best carry the narrative.

The development of a page from roughs to finished pencil layout. The page is broken down from an original script, which will have been sent to the artist by an editor or a scriptwriter, with panels numbered and picture, action, and dialog described.

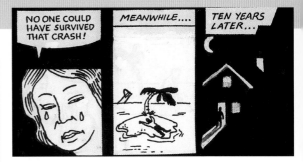

Time and place

In just three panels, using very little detail, an intriguing story is unfolded with the final panel leaving the reader to imagine what happens next. Notice how the cartoonist can leap through time and different locations in each frame.

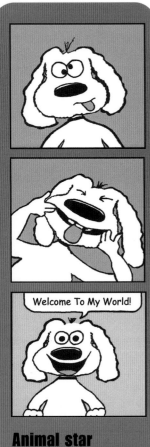

Animal star

A dog or other animal can often be the star of a comic strip—especially a charming, funny one, such as in this example by Anne Wehrley. The smooth color was applied using a computer software program.

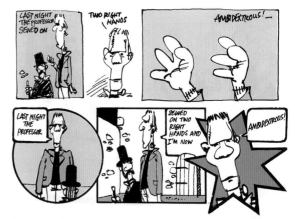

Use of frames

These two examples of a Dr. Frankenstein comic strip illustrate how a more imaginative use of differently shaped frames can make a strip more dynamic. The upper three frames work well, but the lower three frames incorporating a circle, a square, and finally a star shape make it much more interesting visually. Notice how little background detail there is in most frames and how this maintains the focus on the characters.

Silhouettes

One of the most effective methods of dramatically varying your drawings is to use silhouettes. They draw attention because of the strong contrast between black and white on the page and can help to create diverse moods ranging from menace to romance. Use sparingly for the best results.

Silhouettes like this establish a mood of romance.

Silhouettes can portray action.

Silhouettes can focus the attention on characters.

Silhouettes are excellent for an overall view.

Silhouettes can make a scene sinister.

In this comic strip, the second frame uses the silhouette method to focus on the group of figures without being cluttered with detail.

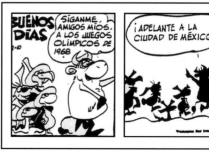

THE GRAPHIC NOVEL

The graphic novel has enjoyed a recent renaissance of popularity. The layout is very much in the cinematic mode with dramatic closeups and wide-angle viewpoints. Fantasy is a common theme, along with dark gothic terror and, of course, science fiction, but new genres are also appearing in line with modern tastes.

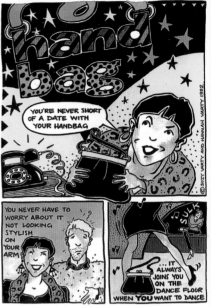

Page layout

The way you lay out a page gives that part of the story a particular mood. A formal layout simply relates a series of events; a splash panel adds force and excitement to one particular event; an informal layout encourages the reader's involvement.

Use of color

This stylishly drawn cartoon strip has a good balance of black and white combined with vivid color to give it great impact for the reader.

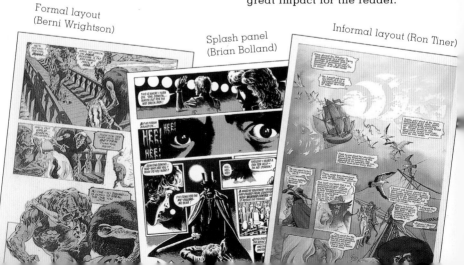

Formal layout
(Berni Wrightson)

Splash panel
(Brian Bolland)

Informal layout (Ron Tiner)

Shots

Like a movie director, you need to be aware that the distance from which you view something—each "shot"—affects the reader's emotional reaction to that part of the story. Over the story as a whole, your choice of shots can entirely transform the reader's concept of the tale.

The long shot is used to orient the reader when there is a change of scene, or a shift in the viewpoint.

Ultra-closeup is used to accentuate the emotion of a single character.

The medium shot can be an action view or a mood-setter.

Use the closeup when you want readers to identify with one character.

A general view conveys the relative positions of characters and surroundings.

The down-shot renders the reader a voyeur—someone watching but not involved.

The up-shot makes the figure more impressive and can be used to add menace.

The angle-shot slightly disorients the reader and can add shock-value to a scene.

GREETING CARDS

Greeting cards require a specialized approach to cartooning. Millions of greeting cards are purchased every year and the demand for new and different cartoons to fill these cards is huge. As the trend for sending cards has broadened from traditional birthday and seasonal greetings, to non-specific cards with a blank panel for personal messages and cards for virtually every occasion you could think of, so the need for appropriate cartoons has increased. The greeting card market is always searching for something new—to be successful, the cartoonist has to be aware of market trends and catch the mood of the moment.

A greeting card is much more than a folded piece of card with a design printed on it. It is an extremely important method of communication—and the reasons for sending cards can vary now from traditional wedding congratulations to get well wishes! Color is always important and adds impact and attracts browsers to the design.

Birthday greetings

A distinctive birthday card. The message inside reads, "Yes, you're really that old! Happy Birthday!"

Best wishes

Inside the card, the message reads, "Now it's your turn...Keep in touch!" This is a general card, not for any special occasion, but for sending between friends. A lot of people increasingly prefer to send greeting cards to express their sentiments, as it is a lot easier than writing a letter. It is another reason why cartoons will always be in big demand for the greeting card industry.

For your 40th
Birthday
we got together

to give you enough
support to last you
the rest of your
Life

I'll Drink
to That!!

Simple and effective

Cartoonist Anne Wehrley used a computer program to add color to a lively group of people and their dogs creating an amusing design for a birthday card.

Christmas time

A simple idea for a Christmas greeting card that manages to be both charming and amusing. The cartoon snowman may be a well worn cliché but it never fails, provided you can inject a little bit of magic into it.

HEY KID I'M
FREEZING
OUT HERE !!

· DAN RUSCITO·

Cards for all occasions

Imagine when the only time people ever sent greeting cards to each other was on birthdays, possibly on Valentine's Day, and at Christmas. The fantastic news for cartoonists is that now there are cards for virtually every day of the year! Here are just a few of the events that you can now buy a card for to send to someone.

- Halloween
- Jewish holidays such as Yom Kippur and Hanukkah—to design for these occasions you need to study what cards are currently on sale.
- Moving home—everyone moves at some time!
- Grandparent's Day
- Christmas—apart from the traditional themes, there is a growing demand for cards with alternative Christmas humor.
- Birth of a child
- Engagement
- Passing your exams or driving test

CARICATURES

What is a caricature? A dictionary might describe it as "a drawing of a person or thing utilizing exaggeration of characteristics." Caricatures can be of anyone—politicians, sporting personalities, pop stars, or just close family and friends.

Caricaturing is a particularly topical branch of cartooning and will always be popular, so if you can make your forte you will always be sure of work. Developing a unique style of drawing is vital to making your caricatures work. It can be quite daunting to sit in front of someone and draw a caricature of them, so it is best to begin by using photographs of famous people to develop your skills. When you are confident of your ability then you can move on to real people. A caricature can be just the face or the whole figure of the person. The acid test of any caricature is that it is recognizable as the person drawn—it is for this reason that really good caricaturists are rare.

Study the work of caricaturists in newspapers and magazines and see what facial features they exaggerate. Look at caricatures by someone like Gerald Scarfe to see some really extreme exaggeration techniques.

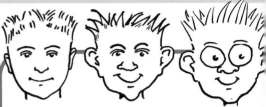

How to get started

A good way of developing your caricaturing skills is to first draw a realistic rendition of the person (left), then do another drawing (middle) that exaggerates features such as the nose, hair, and jaw line. Finish by making a final drawing (right), which goes to extremes while still maintaining the basic head shape. Practice this until you can go directly to the extreme caricature either from a real person sat in front of you or from a photograph.

Expressive

The world-famous opera singer Luciano Pavarotti is ideal for caricaturing and this drawing by Peter Maddocks captures him in a typically expressive gesture. Notice the amusing inclusion of wavy musical notes in this caricature.

Using computers

These caricatures of Mick Jagger by Peter Clarke break away from the traditional hand-drawn caricature. The artist has used a computer to distort and exaggerate scanned in photographic images. Notice the extreme and realistic detail this method produces.

Checkpoints for drawing a caricature

- Decide what features distinguish the essential character of the person.
- What is the basic shape of the person's head?
- The forehead—high or low?
- Hairstyle?
- The nose shape (always a good feature to exaggerate).
- The ears—are they large or small?
- Does the person wear any distinctive clothing?
- Are there any props that are associated strongly with the person (for example, in the case of ex-President Clinton, a cigar). Including props can immediately help the reader identify the person.

CHAPTER FOUR

GOING PROFESSIONAL

How to Generate Ideas

While every cartoonist can gain more proficiency in their drawing skills by applied study, it is also essential to develop a reliable method of generating new and original ideas—otherwise you will be a talented cartoonist with nothing to draw.

Where does a cartoonist get their ideas from? The answer is anywhere and everywhere. A political cartoonist will naturally need to keep up with current affairs, but radio, television, and newspapers are rich sources of ideas for all cartoonists and you never know what could inspire you next.

Become aware of how people behave all around you. Watch them, observing quirky situations and details, and noting expressive gestures and facial movements. Listen to conversations—bus, plane, and train journeys are particularly good for this. The best comedy often comes from exaggerating the familiar and recognizable.

Exaggerating real life

Start by drawing everyday items, and then slowly exaggerate them. The details of this doghouse—the bowl, the bone, and the simple construction—are recognizably true to life, even though they are also cartoonlike. The faucet looks accurately drawn, even though parts of it have been made fatter and the drip is not realistic. The alarm clock is still identifiable as an alarm clock even though it is distorted to show its movement and ringing.

Distorting stock scenarios

An effective way of creating something new is to take a stock situation or cliché and put your own unusual, original spin on it, as in the examples below.

Two stock scenarios—the desert island and the cliché burglar—are mixed together here to create an unusual and slightly bizarre cartoon. It is then up to you as the cartoonist to come up with a rationale for this scenario.

"I'm getting a message from a very nice pair of shoes...sorry, it's your great grandfather!"

A well-used stock scenario for the cartoonist—the fortune teller and her client—is in this case given an unusual spin. Notice that the stock devices of a crystal ball and the name Madam Rosie indicate the scenario immediately, without the need to provide lots of unnecessary details.

THINK FUNNY!

It may seem obvious but it does help if you are a cartoonist to develop an awareness of the humor in everyday life. Masters of comedy take their humor seriously and many study all aspects of what makes humans laugh. There are certain patterns to be found in humor and in why some things make us laugh while others don't. Try reading books analyzing humor for a deeper insight—this can help you to develop new cartoon scenarios.

Equally important is to try adopting a "think-lateral" approach to life—attempt to come up with "off-the-wall" solutions to situations found in everyday life.

Work at those clichés. Everyone is familiar with the classic cliché scenarios that appear in cartoons, such as the desert island or "Waiter! There's a fly in my soup."

These scenarios continue to work provided the gag-line is fresh or topical. Draw your own version of the desert island with castaways and try to think of at least five original captions. This is a good exercise to get your creative mind working.

Always bear in mind that generally a great gag-line will sell a poorly drawn cartoon but a brilliant cartoon drawing may not sell a poor gag-line. Many of the world's most famous cartoonists are not technically fantastic artists but they do know how to put a humorous point across effectively. If you can learn to combine great art with great gags then you will have all the genius necessary for cartoon glory!

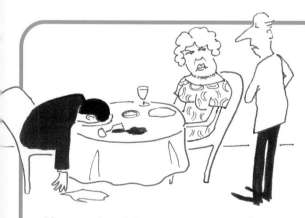

"Sorry madam, it is not management policy to discount the bill if your partner dies."

Unexpected humor

Even the most unlikely of scenarios, such as the death of a diner, can be cartoon material. Here, the unsentimental matter-of-fact comment by the waiter provides some black humor. Try to develop a wry eye to everyday situations and you'll find that you're able to inject humor into almost any circumstances.

Observing and recording

There's no substitute for watching, and gaining inspiration from, real life and real people. Regardless of how incredible and exaggerated your cartoons may become, they will always need to contain details grounded in what is instantly recognizable and realistic.

Get into the habit of recording any and every idea that occurs to you. Ideas will often surprise you at the oddest times, and if you don't record them as soon as possible, you will soon forget them. Always try to carry with you a notepad and pencil, or even a Dictaphone. Note down things which make you laugh and things that surprise you or seem unusual. A digital camera is also a helpful item to carry around, to enable you to record visual inspiration quickly and efficiently.

Learning from other cartoonists

Both new and old jokes can be an endless source of inspiration to create original cartoons and gags. Collect, buy, or borrow as many books on cartoons and of cartoons as you can. Old, out-of-date cartoon books can be a wonderful source of new ideas— simply try rewriting the gag-lines and redrawing the cartoons in your own style and you should be able to produce some great new material.

THE CARTOON IDEAS FILE

There is one item that is absolutely essential for any cartoonist—a cartoon file. This will build into one of the most valuable reference and ideas tools you will ever have. Buy a large storage file or box (A4 is a good size) and begin using it to organize your ideas and sources of inspiration. Into this file you will put any cuttings or photocopies of cartoons or illustrations that particularly catch your eye.

Decide first of all how you are going to categorize your material. There are numerous ways of doing this—you could keep one file entirely for single-panel cartoons, another file for strip cartoons, and yet another for caricatures, for example. The choice is yours. Under these general divisions, create a filing system based on the alphabet, so that in the single-panel cartoons file under "A" you could file all cartoons that contain aircraft, animals, ants, etc. This will help you to quickly locate a cartoon with animals when you need one.

The main use of this kind of ideas file is to compile a collection of a variety of cartoons that will become a superb reference tool—not to copy from but to provide inspiration and spark off your own ideas. The file will also act as a reference point for studying how other cartoonists draw unusual items, characters, places, or interiors.

You will quickly appreciate the value of your own cartoon file. Try to add clippings of cartoons every week and look out for not only good examples of cartoons, but also for those that you feel are not so well executed.

Once you have an "ideas file" you should never again struggle to come up with original cartoon and gag ideas.

QUICK REFERENCE

Let's say that you had to come up with a new cartoon about desert islands. Sitting down in front of a blank piece of paper is about the worst thing you could do. Unless you are a genius you will find that ideas do not just jump instantly into your mind. You will need the stimulus of your ideas file to help inspire you to create new cartoons. How do you do this? Simple! Look up in your cartoon reference file any cartoons under "desert islands" and try to rework the jokes you find by thinking of variations on the gag-lines or by completely redrawing the cartoon in your own style. By doing this

regularly you will sharpen up your cartoonist's eye and mind to be more receptive to generating new cartoon material. And it works! Remember, a professional cartoonist cannot rely upon occasional flashes of inspiration to create new cartoons—editors and publishers require new ideas on a regular basis and often at short notice. Once you get into the "idea-generating" mindset you will find that you will be able to come up with new cartoon ideas with ease and your work will improve in quality.

Be organized
Try and get in the habit of filing your own notes and ideas as well, to enable easy access when you need inspiration fast.

Using the Internet for inspiration
The Internet is a marvelous resource for obtaining reference material for your cartoons file. You can use a search engine to find many thousands of websites dealing with cartoons. Instead of cutting out cartoons from magazines, you can print off any material that interests or inspires you. Accessing cartoons on the Internet means you can keep right up to date on topical issues and observe any new styles that are developing. Try looking at cartoon sites where you do not understand the language and observe the differing styles of drawing that may give you ideas for improving your own cartoons.

HOW TO SELL YOUR CARTOONS

In many respects creating and drawing cartoons is the enjoyable side of the business—selling your work is much more of a challenge. Being a freelance cartoonist can be a profitable career but you need to approach it in a professional manner to maximise your chances of being successful.

To give yourself the best possibility of selling your cartoons, study the market carefully before submitting anything. Only submit work to a publication once you have ascertained their specific requirements. Knowing what they want and only sending in cartoons that you know are suitable will greatly increase your chances of having your work accepted for publication. It is a waste of your time and the publication's if you send in totally inappropriate and unsuitable cartoons—for instance, cartoons of car mechanics are not likely to be of any use or interest to a gardening magazine.

BEATING THE COMPETITION

There are many thousands of would-be cartoonists in the world all competing for work. The biggest mistake they all make is to start by submitting their work to the most

Presenting your work

When visiting a potential client always take along a small portfolio containing an appropriate selection of your cartoon work—making sure it is only your very best work. Allow the client to browse through your portfolio at their own pace and be available to answer questions.

well-known publications where the competition is fierce and chances of having work accepted are slim. To give yourself the best possible chance of success, start by sending your cartoons to smaller, niche market publications, of which there are thousands. The pay may be much less to begin with but once you have got a foothold in the commercial world you can begin building a reputation from which you can progress to larger publications.

THINK OUTSIDE THE BOX

The market for cartoons is a lot wider than you might think. Study any and all printed material that comes your way, from grocery store handouts to takeaway menus. You will find that cartoons are used a lot and since somebody has to provide them, why not you? Almost any business or individual that markets to the public will at some time or other need to enlist the skills of an illustrator or cartoonist. Your cartooning skills will always be in demand if you take the time and effort to seek out those in need. Perhaps there is a page in your local community newspaper that could be enlivened by some cartoons? Never be afraid of making speculative approaches, suggesting your cartoon ideas. Remember to emphasize the benefits to the intended publication that your cartoons could generate. Editors are not interested in being philanthropic—they will need to be convinced that what you have to offer will benefit them, their publication, and their readers.

HOT TIP!

Always be aware that there is a lot of money to be made from cartoons so it literally pays you to be business-like in your dealings with publishers and editors. Leave the funny stuff in your cartoons!

HOW TO PRICE YOUR WORK

When you begin producing cartoons professionally and for publication, you have the right to expect to be paid for your work. Never produce a cartoon and give it away for free—unless it is beneficial to you for publicity purposes, or for a charitable cause. Being a cartoonist is a skilled art and occupation in exactly the same way as a writer, actor, or painter. As a professional you expect to be paid for your services. It is only when you begin to be paid for your work that you leave the ranks of the amateurs.

HOW MUCH?

There is no industry standard of pay rates for cartoons so fees will differ from one publication to another and from one country to another. Try to find out what particular magazines pay before submitting your work—write to the editor or telephone them. If a publication you have contacted has never previously printed a cartoon then you need to have a realistic figure in mind to quote. Remember it is not only the artwork the editor is buying—it is also the thinking time and creative mind that produced the cartoon. As a general rule you should aim for at least $35 per hour per single cartoon. Time yourself to see how long it takes you to produce an original cartoon and then you will know how much of your time you are expecting to be paid for. Be realistic, though, about how much the publication you are submitting to can afford—a local, small-circulation publication is unlikely to be able to afford as much as a national daily

Agree the fee

Don't worry about how much you will be paid for your cartoons since with a sensible attitude and by producing good work you will find that in general all publishers will pay you a fair fee. The main thing to remember is to have an agreed fee before you commence a cartoon assignment—then you can stop worrying about "how much?" and just enjoy cartooning!

publication. Be prepared to negotiate on your fee. For example, if there is a likelihood of a regular cartoon spot for you then you can afford to accept smaller fees than you would for just a one-off cartoon appearing once only.

Getting paid

A purchase order is a legal document laying out the rights and duties of both publisher and commissioned artist. You will usually be expected to sign a purchase order and return it with an invoice when your work is complete. Just as it is important to present your cartoon artwork professionally and on time so you must submit your invoice for payment in a professional manner.

Description of work: this is a precis of the written brief.

Deliver by: the required deadline.

Conditions: always check the small print for copyright terms.

Address your invoice to the person who commissioned you, using their full name and title.

Itemize the work you have supplied.

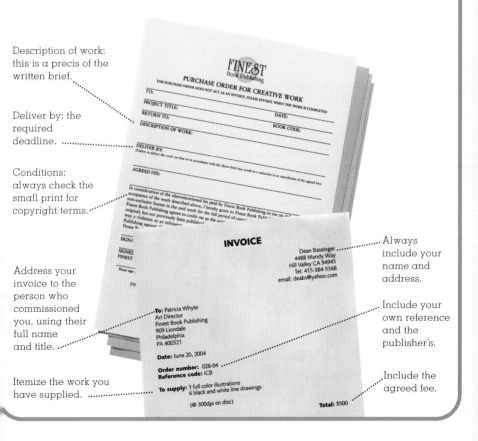

Always include your name and address.

Include your own reference and the publisher's.

Include the agreed fee.

FINEST
Book Publishing

PURCHASE ORDER FOR CREATIVE WORK
THIS PURCHASE ORDER DOES NOT ACT AS AN INVOICE. PLEASE INVOICE WHEN THE WORK IS COMPLETED

TO:

PROJECT TITLE:

RETURN TO: DATE:

DESCRIPTION OF WORK: BOOK CODE:

DELIVER BY:

AGREED FEE:

INVOICE

Dean Bassinger
4488 Mandy Way
Hill Valley CA 94941
Tel: 415-384-5368
email: deabs@yahoo.com

To: Patricia Whyte
Art Director
Finest Book Publishing
909 Liondale
Philadelphia
PA 400321

Date: June 20, 2004

Order number: 028-04
Reference code: ICB

To supply: 3 full color illustrations
6 black and white line drawings
(@ 300dpi on disc)

Total: $500

How to take a brief

When you are commissioned to produce cartoon work (rather than submitting work on spec), you will be given a brief. This is a guide from the editor/publisher describing what they require from you. This will tell you vital information, such as whether the cartoon should be in color or black and white, and the size of the page that the cartoon is required to fit into. You should make sure that you understand everything in the brief before starting work, because if you don't you could spend hours creating a cartoon that is ultimately useless and for which you will not be paid.

Once you have agreed to work to a specific brief for a specific fee and deadline, it is up to you to keep to the terms of the agreement. You have no right to later demand more time or money because the work takes longer than you originally estimated. If a real disaster prevents you from delivering on time, let the client know as soon as you possibly can.

Always stick to the brief even if you have a "better idea" halfway through the job; you are commissioned to supply only what was agreed upon in the original brief.

Prove yourself able to meet deadlines and get the job done as required and publishers and editors will recognize you as a reliable person to deal with and with luck will offer you more commissions in the future.

Meeting your brief

- Provide the correct size or proportion of artwork as specified. Find out whether the editor wants it the same size as the printed version or larger.
- Is the artwork required in black and white or in color? Black and white artwork is for reproduction in line only, whereas in half-tones gray washes can also be included.
- Are you allowed to include any words or captions? If so, should they be handwritten or set in type for printing?
- Are you clear on the fees to be paid and are they acceptable?
- Prior to sending in finished artwork the publisher may ask you to present rough sketches for approval. Minor amendments may be requested and this is part of the job—but if the client wants the artwork to be completely reworked, then try to negotiate an extra fee for this.
- Deadlines should always be met. If you feel a proposed deadline is unrealistic, either negotiate an extension before beginning or refuse the work.
- When you send finished artwork to the client ensure it is well packed and insured against loss. Finished artwork is usually presented with a mask, or window mount, bordering the image and a protective cover sheet of paper or clear acetate over the mask. Make sure the envelope is card backed to prevent the artwork being crushed or bent in the post.

From call to wall

A brief can come by phone, mail, email, or as the result of a visit to a client.

Once briefed, you can begin work. The client may want to see roughs of how you envisage the job. When these have been approved, you can proceed.

Always be prepared to do amendments and revisions, however, if the client requests them.

Once any changes have been taken in, submit the finished artwork by mail, email, or in person.

Then wait for the check to arrive, and start pursuing the next big job.

Remember the final aspect of the job—seeing your finished work published.

COPYRIGHT

As a cartoonist you need to be aware of the copyright law and how it applies to and affects you and your original work. Actual ideas or jokes are very difficult to copyright—until the point when they are committed to a tangible format such as a drawing or piece of writing. Copying a work already printed in a publication and attempting to pass it off as your own work is breaking the law and infringes the copyright of the original creator.

Copyright protection of your own work is also important because it allows you to prevent the unauthorized use of it by others without your express permission. If you do grant permission for another party to use your work then you are entitled to charge a fee for reproduction rights.

Whenever you create an original cartoon you should get into the habit of writing on the back of the artwork or just below it the copyright symbol © or the word "copyright" followed by your name and year of origination.

US copyright law

Although you do not need to register your copyright to have it protected, no action for infringement of copyright can be undertaken in the US unless the copyright of a work is registered.

To register copyright, a copyright notice should appear somewhere in the published work. Within three months of publication of such work, the copyright owner or the owner of the exclusive right of publication must deposit within the Copyright Office two complete copies of the work for the use of the Library of Congress. Publication without a notice or with an incorrect notice will not automatically invalidate the copyright or affect the ownership. However, any error or omission should be corrected as soon as possible to prevent the eventual loss of protection. Contact the US Copyright Office website www.loc.gov/copyright for up-to-date details, fees, and forms.

WHO HAS THE COPYRIGHT?

Usually when you obtain a publishing agreement it will be made clear to you who has the ownership of your artwork and its copyright. Copyright will usually be with the publisher; for advertising and book illustration work, you may be asked to assign copyright totally, to enable the image to be published in any market your client enters without further reference to you. Alternatively you may be

surrendering rights for specific uses only. Some publishers may pay you a one-off fee but no royalty payments (a payment for each book sold), while others may pay a small fee and a higher percentage of royalty payments. Always read through carefully any publishing contract before you sign it so you understand fully what rights you are signing away. Publishers are in business to make money, but will deal with you honorably and will explain the contract to you, so never be afraid to query any aspect you are unsure about.

Photocopying

Photocopying printed matter from magazines, newspapers, and books without written permission from the publisher is illegal in many countries. Certainly photocopying anything and reproducing it in other printed material or electronically requires express permission from the copyright holder(s).

"Duplicating yourself without official permission again, Jenkins?"

FILING AND STORING CARTOONS

When you first start out cartooning you never imagine that within a very short time you will have so many that you need to use a filing and storing system. Twenty cartoons soon become two hundred and that is when you have to have a methodical method of filing all of them, so that you can easily and quickly retrieve them when needed. A good filing system will save you time and worry, especially when you are sending out cartoons to many different publications at once.

An effective filing system will help you to keep track of work and the accompanying letters that you send to clients. It is not difficult. Every time you send artwork to a prospective customer, make a copy of it and file it with a unique reference number or code. You also need to keep a record of the date sent and to whom and whether it was accepted or rejected and returned. This helps you to keep an accurate check on where your cartoons are and who is and who is not buying them. It also prevents you from sending the same cartoons to a client twice!

Over time, your records will also show you which cartoons are selling and which are not. Remember that cartoons that are not selling can always be redrawn or the caption updated—sometimes only a very minor adjustment to a cartoon is all that's needed to turn it into a very saleable item.

Recipient Fly fishing weekly – Dave Salmon, Art Editor.					
Cartoons sent	Date	Accepted	Rejected & returned	Payment	Publishing date
numbers 18,19,20, 22,48	2nd Jan	18, 19	20,22, 48	£60	March issue

Recipient Woodworkers monthly, Tim Pinewood, Cartoon Editor.					
Cartoons sent	Date	Accepted	Rejected & returned		
3,6,7, 19+20, 22	21st Jan	7,20	3,6, 19,20 22		

Keep good records

A good filing system will enable you to quickly locate any cartoon you have drawn and save time—nothing is worse than not being able to find that cartoon you drew last week and want to work on now!

Storing your work digitally

Once you've started scanning and creating images on the computer, you'll soon find that your hard disk will eventually run out of space. And the fuller the hard disk, the greater the chances of it crashing when it is needed most.

Storing electronic artwork is much like storing any other digital file. The main thing to remember is to back up your hard disk regularly. This is vitally important! Without backing up, you could lose everything in one fell swoop.

Basically, backing up means copying your entire hard disk to some other storage medium periodically. There are programs available to help you do this, especially if you want to do cumulative backups (ie, backups that you add to over time, whenever you've gathered enough new material, rather than backing up the whole lot at once). External hard drives are another excellent solution for backup—if you can afford one. You can also partition them, and use different partitions for different areas of backup. If your main hard disk is getting full, they're also great to give you more usable space. They're certainly the fastest of all the options, but also the least portable. Below are some other ways of storing digital files.

Zip disks

Zip disks are removable hard disks that come in two sizes, 100MB and 250MB, and need a special drive to read/write them. The disks are fairly expensive unless you buy them in bulk, but they are good for sending files to publishers.

CD writers

The best all-around solution is a CD writer. Using special writable and re-writable CDs, you can fit up to 700MB on a single disk, allowing you to back up large hard disks cheaply. You can get CD writers that connect to Macs and PCs externally or internally.

GET PROFESSIONAL

By presenting yourself in a professional manner you will always have much more chance of being successful in the commercial world. Having an eye-catching letterhead is essential and a great start but it does not stop there—you also need to keep to deadlines when you supply cartoon artwork, you need to know how to say "no" to undertaking work that you cannot complete because of other commitments, and you always need to be looking for work to keep busy. Your correspondence with editors and publishers needs to be concise and answered promptly just as telephone or

text messages should be replied to as soon as possible. Attending to these points will define you as a reliable and good cartoonist in the eyes of editors and publishers and is very likely to bring you more commissions.

When you are established as a professional cartoonist your record-keeping needs to be faultless. You need to know at a glance which cartoons you have sent to who and where, and whether they have been sold or rejected (see Filing and storing cartoons, page 150). You will always get rejection slips—they are part of the business of being a cartoonist unfortunately—but you do not want to make the mistake of re-sending rejected cartoons back to the same publisher, or worse, to an out-of-date company address or contact name. Keep meticulous records, including copies of invoices, and keep accounts of income and expenses as separate records. Always keep copies of your cartoon work that is published in magazines, newspapers, and books since these will be part of your portfolio to showcase your work to new prospective clients.

Self-promotion

Professional-looking business cards and letterheads are essential. Make sure your name and contact details are prominent and clear.

Pitching your work

To avoid wasting time, effort, and expense, follow a few simple guidelines when making your business contacts and sending in work on spec:

- Make sure you have an up-to-date address for the publication or agency you are applying to. Even the largest companies can move premises. Always telephone to double-check an address if the company is new to you.
- Study the publication's areas of special interest and the way in which their cartoons are presented. Make sure that both the style and content of the work you are submitting will be appropriate to the publication's market.
- Send your work to a specific editor or art director—this is much more effective than a general submission. When deciding who to target, keep in mind that the editorial content of your cartoons may be as important as the drawing style in catching someone's eye. For large-scale publications, check whether there is a specialist cartoon editor.

- Make sure that the letter or email you send with your submission is clear, concise, and easy to understand. Ask someone to proofread it before sending— spelling mistakes never create a good impression.
- Follow up your submission with an email or a phone call a week or so later. You can pretend to be checking that your work has arrived safely, but in reality, this is an excellent way of jogging an editor's memory.

Emailing files

Don't try to send anything too large over the Internet using an email program. The maximum is about 10MB at a time, and even this can be risky. If you do have to send large files, ask your publisher if they have a File Transfer Protocol server that you can use to upload.

MARKETING YOUR WORK GLOBALLY

What you are marketing as a cartoonist is a combination of ideas and drawings. These skills are not limited to merely your own country—they can be sold globally if you put in the time and effort. Increasing public access to high technology communications systems means that direct conversations with a potential client on the opposite side of the world are both possible and inexpensive via email and the Internet.

As a professional cartoonist you should try to establish your own website to showcase your work and to allow potential clients to contact you immediately. There are lots of free ready-made website templates onto which you can place your cartoon work and contact details. Having your own website means instant exposure globally for you as a cartoonist, making you and your work available to a much wider market.

You can also use the Internet to search for publishers who may require the services of a cartoonist. If the publisher is located in a country other than your own then you need to research their credentials. You can do this online or by searching in foreign trade directories at a business library to establish their status and confirm addresses.

Humor is not the same all over the world—what is amusing in the US may not be amusing in, say, China and vice versa. Political cartoons in particular are usually meant for a very specific audience and do not travel well. Some subject matter could also be quite acceptable in one country yet be offensive in another— so try to be aware of different social and cultural taboos to avoid submitting inappropriate work to a foreign publisher who may well be insulted by it.

Global humor

The fast-food burger bar has become fairly ubiquitous in all countries and this means that cartoons about them travel well. Here, the lackadaisical response to the irate customer is cynical but amusing.

Setting up a website

Step-by-step details of how to set up a website would take up a whole book, but here are a few pointers to get you started.

- Free web space: There is loads to be had, so cast around and find a site where you can post your files for nothing.
- Macromedia Flash and Dreamweaver: You can download 30-day trial versions of these essential programs from the macromedia.com website. You can also find all kinds of great tutorials online for these applications.
- Free Internet Service Provider: You don't necessarily have to pay for your ISP. A few ISPs do offer free internet connections. All you pay for is the phone call. However, a better solution is to splash out for broadband. If you are spending a lot of time online, having broadband means you do not pay for the connections to the internet—and it is a lot quicker to use.

GIF and JPEG images

Remember to use the right file format for your images. The most common formats are GIF and JPEG. In general, GIFs should only be used for images that have mostly flat colors, because these will compress well (and you can only use a maximum of 256 colors anyway). Images that are more like photographs, because they have a wide range of tonal values, should be saved as JPEGs. These show a larger number of colors and are excellent with tonal values, but every time you save a JPEG, you lose a little more picture information, so only save images after you have finished working with them.

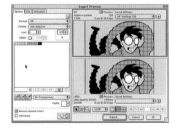

Images for the web

When drawing for web pages, you can scan in drawings and touch them up in a paint program, or create the whole thing from scratch in the paint program itself. The most important factor is how long the page will take to load in the reader's browser—if it is too large, most people won't bother.

SYNDICATION

Syndication entails the distribution of your cartoons to as wide an audience as possible—a comic strip, for example, may appear regularly in several newspapers; not only that, but it could also be syndicated globally and appear in translation. If your cartoon work is syndicated it will generate more income than if it was contracted to appear in just one journal. There are syndication agencies that will undertake the selling and licensing of your cartoons but this is a very competitive market and is difficult to break into until you have become professionally established as a cartoonist with a lot of published work to your name.

The most successful comic strips such as Garfield and Peanuts are syndicated all over the world and have been for decades, providing a high income for the cartoonists. An established syndicated cartoon can also result in spin-offs such as merchandise, greeting cards, and soft toys—providing a further lucrative income.

Money, money, money

Syndication for your cartoons means much more money and on a regular basis. Your cartoons are reproduced in a number of publications, possibly nationwide or even globally, and you are paid a fee each time they appear in print. This could provide a regular source of revenue over many years or even a lifetime if your cartoons prove popular.

Try collaboration

If you want to create and syndicate a long-running comic strip it is essential to understand that you will need to be able to constantly generate new ideas, possibly over many years. A number of comic strips are produced by two people, a cartoonist and a scriptwriter. This is a system that can work very well. Not only is the workload shared, but another person can help by providing a different viewpoint and a fresh perspective.

The comic strip below—"She's got the house" by Fred Balser and Anne Wehrley—is a good example of cartoonist and scriptwriter collaboration. Their work together produces a lot of wry humor from contemporary male–female relationships.

She got the *House* By Fred Balser & Anne Wehrley

Dad, Is It True That In Some Countries A Man Doesn't Know His Wife Until They Are Married?

PopCorn!! Peanuts!!

Son, That Happens In Most Countries!

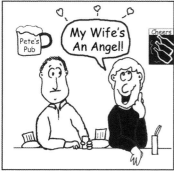

She got the *House* by Fred Balser & Anne Wehrley

Pete's Pub

My Wife's An Angel!

Cheers

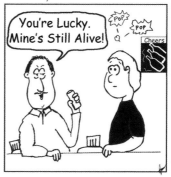

You're Lucky. Mine's Still Alive!

POP POP

Cheers

THE GREETING CARDS MARKET

One of the biggest opportunities for professional cartoonists is the greeting cards industry. People are spending and sending more and more greeting cards each year, especially in the USA and UK. There is a constant and growing demand for cartoon designs for cards and if you have the aptitude for this genre of cartooning then you could be very successful and establish a great career.

Cute and funny cartoons are always popular on greeting cards so there is lots of work for cartoonists!

The largest greeting card market in the world is in the US, because there are so many "sending-days," much more than in any other country. Greeting cards are sent on Thanksgiving Day, Independence Day, Halloween, Mother's Day, and dozens more besides, as well as the non-specific cards with thoughts and good wishes that are sent between friends. To break into this specialized and lucrative area of cartooning it is necessary to do thorough market research before submitting your cartoon designs to publishers. It is worthwhile, however, because there is a lot of cartoon work available and many greeting cards publishers will accept freelance contributors.

When submitting your cartoon designs to card publishers it is good practice to send a preliminary letter first asking for their design briefs, current requirements, style, and fees paid. In your letter it is advisable to include a concise résumé of yourself and any published cartoon credits. You may be required by some publishers to sign a disclosure agreement, often before they will look at your work—this is designed to

protect all parties from possible future accusations of theft of ideas or breach of copyright. Never send your original cartoon artwork, but always good-quality photocopies or computer laser printouts in black and white or full color, as most publishers will not be prepared to accept responsibility for any loss of artwork.

As an example of how a greeting cards company operates it is worth noting that out of about 200 or more cartoonists each month who send in samples of their work, only between one and four will be asked to come in to the office for an appointment. It is a very competitive market. A good idea to

get yourself noticed is to have some postcards printed showing your very best cartoons— commissioning directors are more likely to keep these on their desk as an aide-memoiré to contact you in the future.

As well as the major card companies, there are much smaller niche markets for the cartoonist to approach, such as local businesses who often send out greeting cards at various times of the year. Although they may usually buy off-the-shelf cards you could offer them your original work to use instead. A little prior research will give you ideas for cartoon illustrations appropriate to each business.

A sample brief

The following points are from a real brief for greeting cards and indicates what the industry expects from cartoonists.

- We are publishing a vast amount of new products and need lots of new ideas and artwork on a daily basis.
- We publish cards that are contemporary and topical.
- We do not wish to publish material that is sexist, homophobic, or racist. We will not publish material referring to sensitive subjects such as child abuse, AIDS, incest, disabilities, or any illegal activity.

- Jokes about famous people particularly anything that is clearly detrimental or libelous is not acceptable, neither are depictions of well-known named brands that may be protected by copyright laws.
- We prefer a cartoon style that is not too stylized. We use contemporary images that the sender and recipient can identify with. Human and animal cartoon characters should look modern (in their clothing and accessories, for example) and lots of color should be used to liven up the scenes.

E-CARDS

Cartoon-style e-cards are becoming increasingly popular because they are so easy and quick to use. Electronic cards can be sent via a computer to any global destination without postage charges and they arrive instantly. They can also make use of new media to incorporate animation and sound, which gives the recipient a visual and aural experience that traditional paper cards cannot match.

The good news for cartoonists is that e-cards offer fantastic opportunities for originating, designing, and creating artwork. The demand for new, innovative e-card designs is ever increasing so the cartoonist who can develop original ideas and characters will always be in demand by publishers. Although cartoon and e-cards can be totally originated on the computer, using software such as Corel Draw and animated with Macromedia Flash, many more can be drawn using traditional materials such as pen and paper and then scanned into the software to be enhanced and animated in digital format.

Although e-cards are moving to the forefront of the greeting card market, the familiar and traditional occasions still dominate, such as birthdays, Christmas, and get well. However, these are supplemented by contemporary and alternative greetings, so there is still plenty of scope to be imaginative in subject and content.

Get well

Sending a sick friend a humorous cartoon greeting to get well is an ideal subject for an e-card. Using lots of bright colors and fancy lettering help to make the message lively.

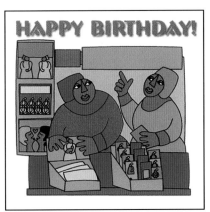

Animate it!

An e-card like this can be animated to make it really special—for instance, the woman could wave her arm backward and forward as the words "Happy Birthday" float into the sky.

Selling your cartoons to e-card companies

A quick search of the Internet will reveal how popular e-cards are and websites offering them need a constant supply of ideas and artwork to refresh their ranges. Look at eToon.com, for instance, who are always looking for new e-card material.

To adopt a truly professional approach, you should create your own personal website displaying your e-card designs. Then send any company you wish to approach an email with your website address inviting them to view your work.

Payment is usually clearly stated, although you will find it varies tremendously with e-card companies so keep up to date with fees by checking e-card websites regularly.

HOT TIP!

M-cards or Mobile cards are digital greeting cards sent from one cell phone to another in a GIF file format. It only costs a couple of dollars to send one and they can be viewed on almost any modern cell phone. This form of greeting card has the potential to become hugely popular and promises to be a good market for selling cartoons. Look at the website of DevilCards.com to see current examples of m-cards. They will also buy ideas for m-cards.

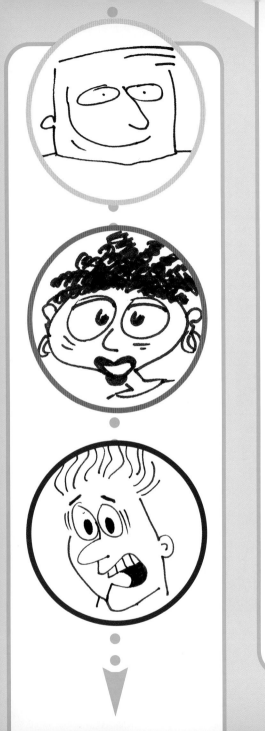

CHAPTER FIVE

EXPRESSIONS FILE

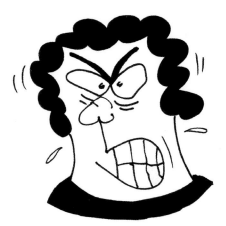

ANGER

Facial expressions offer a marvelous opportunity for a cartoonist to really exaggerate and distort the face well beyond what is possible with a real human face. As a cartoonist you can use simplification and distortion to express varying degrees of anger with great success and humor.

In cartoons it is vital that the facial expressions on the characters you draw convey exactly the feeling required to make the cartoon effective. Get the wrong expression on a face and the humor of the cartoon will not be clear. Facial expressions of anger in a cartoon can range from slightly annoyed to absolutely furious!

Female

1. In the cartoon world, facial features only need a few simple lines to begin to transform this tranquil-looking female into...

Male

1. This male character looks a bit docile—so let's start to make him angry!

Female profile

1. Now try the same techniques on a female head in profile. Right now she is totally peaceful.

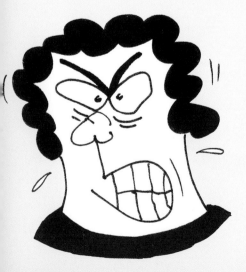

.▶

2. ...a slightly angry mood. Notice the only lines added are the downward sloping eyebrows—an easy and very effective method to give the face an instant angry look.

.▶

3. Increase the anger with lines around the eyes and thick dark lines under the eyes. Notice the mouth with clenched teeth showing—this female is getting really angry now!

.▶

2. Simply add downward sloping eyebrows and he instantly looks slightly annoyed with something or someone.

.▶

3. Even steeper sloping eyebrows with lines around the eyes, a snarling mouth full of clenched teeth—throw in some flying sweat beads and hey-presto!

.▶

2. Put some gritted teeth in, the sloping downward eyebrows, and a few action lines, and things begin to hot up.

.▶

3. Now make her mega mad with bigger teeth, flying sweat beads, and lines around the eye.

Male profile

1. See how easily you can make your cartoon face angry. This man is quite calm and serene.

2. Use the sloping eyebrow technique, a snarling wavy mouth full of teeth, then a few flying sweat beads and action lines to indicate a bit of shaking going on and this man is suddenly very angry.

The front view of these heads show the classic signs of anger. Notice the massive, gritted teeth (always exaggerate for the best effect) and sweat beads.

Lots of bared teeth and black round the eyes all help to get the look of anger across.

Once you have perfected the methods of conveying anger you can really distort the face to get strong emotions showing. Notice how an exclamation mark can also be used to indicate anger.

3. Really thicken the lines under his eyes and alter the mouth shape to get him even more irritated. When you're a cartoonist all you need are a few strokes of your pen to generate anger.

HOT TIP!

Devices such as flying sweat beads, action lines, exclamation marks, and downward sloping eyebrows are the classic cartoon techniques for indicating anger and they can be applied equally well to cartoon animals.

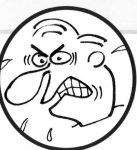

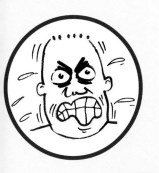

The more you add thick black lines around the eyes, the more it increases the angry look of your cartoon face.

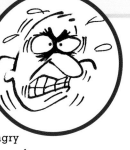

Make the hair on the head ragged and enlarge the nose. It's all good fun and great for an angry look!

JOY

One of the best ways of expressing joy in the faces of cartoon characters is by exaggerating the size of the smile and the teeth. The eyes can be drawn open and large or closed. Experiment by adding flying sweat beads and action lines to emphasize the joyful emotions. If you look at real people showing joy you will be able to notice the facial changes taking place as they laugh and smile—then you can learn to exaggerate them. For instance, look at how the face creases around the eyes and mouth when someone laughs and try adding crease lines to your cartoon faces. Study animated movies of cartoon characters and see how they portray joy. Use the same techniques and you'll soon have an array of blissful cartoon characters.

Female

1. The beginning signs of joy can be indicated by a wide smile and a little dash directly underneath.

Male

1. This male cartoon face has a nice wide smile that anyone would be proud of—just a simple curve is all it takes.

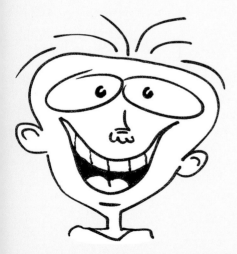

2. The real fun starts when you open the mouth and fill it with teeth! Notice that the smile is lopsided and actually begins level with the eyes (impossible in real people but this is cartoon world so it works) and ends just under the nose.

3. Complete and utter joy is shown by the wide banana-shaped mouth, now with two rows of teeth showing and crease lines either side. Try this on your own cartoon characters and make them full of joy.

2. The same curve for the mouth is present, but this time it has another curve below it and some teeth have been added to bring increased joy to this man's face.

3. Manic joy comes complete with an enormous grin that is literally ear-to-ear with perfect teeth showing.

SORROW

Cartoonists can condense a whole lot of information into a cartoon using just a few lines and marks. Those few lines can instill incredible emotion and none more so than those that make a cartoon character look sorrowful. This is a powerful emotion, but it can also be made amusing in the context of a cartoon.

The main ingredients of sorrow in cartoon terms are the half-closed eyelids, the slanting downward eyebrows, and of course the flying tears, which are just the same as the flying sweat beads.

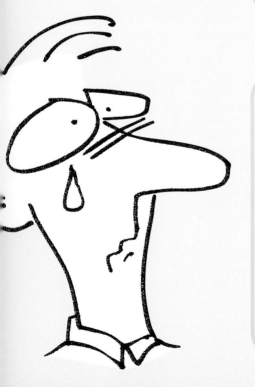

In this cartoon, notice the effect of the shape of the open mouth—with no teeth showing.

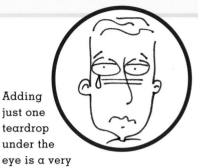

Float the words "Boo-Hoo" above the character's head in traditional cartoon style just to make sure everyone knows the sorrow of the situation. Black under the eyes is another device that intensifies sorrow.

Adding just one teardrop under the eye is a very effective method of showing grief in a cartoon character. Also notice the horizontal lines under the eyes.

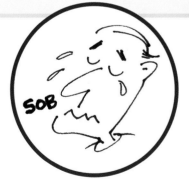

The eyes are both slanting, as is the mouth, in this variation.

Put the word "Sob" alongside the head just to make sure your readers empathize with this cartoon character.

BOREDOM

Although boredom is quite a negative and dull emotion, in cartooning terms it can be expressed quite vividly. Use these techniques to convey good solid boredom.

This character is so bored that his tongue is hanging out. The cartoon device of a black cloud floating above the head indicates a gloomy or bored state of mind. The lidded eyes and black lines on the cheeks all add to the boredom factor.

Drooping mouth, lines under the eyes, and that vacant stare tell you that this character is bored!

Notice here how the mouth is just a line, slightly down-turned at the end, and how the lines under the eyes suggest that this character is really fed-up.

Multiple lines both below and above the eyes create a tired and bored look, supplemented by the short horizontal line for the mouth.

Increase the lines above and below the eyes and drop a dot below the mouth—this man is really bored.

A cartoon profile means that you can concentrate on just one eye to create a bored expression. A heavy eyelid combined with lines under the eye and a neutral, slightly downward line for the mouth creates a perfectly bored character.

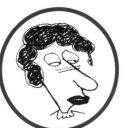

Boredom in female faces can be shown by heavily-lidded eyes and pouting lips. Notice how moving the pupils to the corner of the eye emphasizes the bored look.

Capture the classic cartoon "bored look" by drawing lidded eyes and half-pupils, along with a couple of lines below—simple! Notice the shape of the eyes is elliptical, which also helps to show boredom in the face.

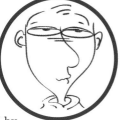

FEAR AND HORROR

Fear and horror are closely-linked emotions and in the cartoon face you can really make good use of a number of devices to create quivering, shaking, and traumatised characters—great fun! The cartoon tongue comes into its own with fear and horror as do clenched teeth and sweat beads. Throw in some action lines to make the face tremble and you are all ready to frighten the life out of them!

Practice your skills by drawing a bland cartoon face and then redrawing it using some of the techniques shown here to show fear and horror.

Open up the mouth and let the big tongue hang out from the center—this is a great cartoon device to indicate fear. Notice the shape of the open mouth. Plenty of sweat beads flying off the face also help increase the fear factor

Words can be very effectively employed in cartoons to amplify emotions —in this cartoon, placing "AHHH" near the character's mouth helps to make the scene more intense and amusing.

The classic clenched teeth look—notice how the lower lip appears to be being sucked into the mouth. Eyebrows very solid and angled upward help the overall effect so much that you almost feel sorry for him.

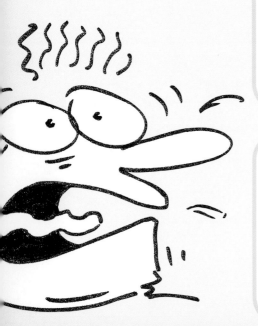

Notice in this cartoon that the tongue is coming from the bottom of the mouth to give a slightly different effect. The upper lip is also drawn using straight lines. Also note the lines above the eyes.

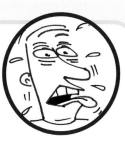

Flying sweat beads are great fun to use but always make sure you keep them off the cartoon face itself—otherwise it will look like your character has contracted some horrible disease like the unfortunate man shown below!

This female character has hair waving in right and action lines radiating from her face to indicate shock and surprise—all excellent tricks of the cartoonist to create a shock-horror look.

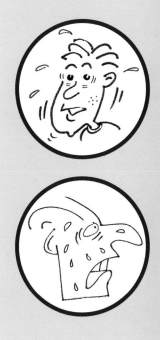

A front view of the cartoon head showing an elliptical-shaped mouth with tongue and upper teeth visible.

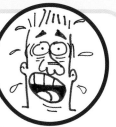

SURPRISE

Cartoon characters are constantly getting all kinds of surprises in comic strips as well as in single-panel cartoons so you must be able to draw this expression regularly and effectively to make your cartoons enjoyable. Bear in mind that very often you will be able to include the whole body of your cartoon character and this gives you the opportunity to exaggerate the level of surprise even more. As you may well guess in the cartoon surprise face there are lots of action lines.

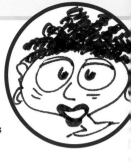

Massive eyes and a tiny open mouth are the components that make this woman look surprised.

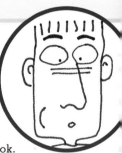

A front view of the cartoon head with just a small circle for the mouth to give the surprised look. Notice also the pupils of the eyes are close together with eyebrows raised.

You can almost hear the gasp from this cartoon face as he is surprised—the use of the exclamation mark accentuates the action.

From the side view, you can see the mouth is open but with no teeth showing. Action lines shake the head.

Gaping mouth and hair standing on end— classic cartoon touches give this character a big surprise.

Another example of the small circle for a mouth. This time the lines are omitted from under the eyes.

An unexpected mild surprise here—notice the action lines to indicate he has turned his head.

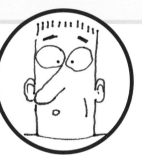

A front view with just a small circle for the mouth to give a surprised look. The pupils of the eyes are also close together with eyebrows raised.

Another example of the small circle for a mouth. This time the lines are omitted from under the eyes.

THINKING

The eyelids play a major role in getting characters to look as though they are thinking. The action lines tend to take a back seat but the line of the mouth becomes important in getting just the right expression of deep thought or just pondering a second or two. Capturing a thinking look in cartoon terms doesn't need to be difficult if you study the methods shown here. Remember that all cartoon facial expressions are simply a form of visual shorthand that the viewer interprets almost subconsciously.

Creating a thinking head is easy enough when you realize the importance of the eyelids—half closed or almost completely shut they indicate thinking.

Really pout those lips and give the eye a grafty look to create a woman who is really pondering over something.

Devices can be used to tell us what the character is thinking about—the heart floating above the man's head and his eyelids at a sloping angle plus the sloping eyebrows mean that love is on his mind.

Downward sloping eyelids and one up-raised eyebrow suggest this character is deep in thought.

Drawing the cartoon head turned away slightly allows you to draw the eyelids almost closed. The short and slightly downturned mouth line adds to the suggestion of thought.

A sideways glance with one eyebrow raised is another surefire method of suggesting thought.

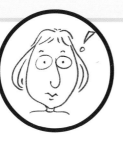

Try raising the eyebrows slightly to give a more quizzical look. Using small pupils and a closed mouth further suggests deep thought.

Using the cartoon device of an exclamation mark above or to the side of the head indicates a sudden thought, perhaps an alarming one.

This character, with one eye wide open, is much more likely to be thinking actively about what is going on near him.

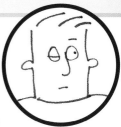

DEVIOUS AND SLY

When you want your cartoon characters to get up to all kinds of tricks and adventures you need to be able to give them the occasional sly look and you can do this easily with a few tricks.

Once again the eye shapes and eyebrows to a large extent dictate the mood in cartoon characters—gritted teeth can also play a role in creating a sly expression.

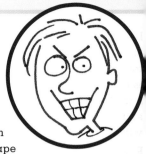

A nasty sly look requires gritted teeth in an almost upside down pyramid shape and down slanted eyebrows. Notice the extension lines to the mouth going up to the cheek—these are an important feature in the sly look.

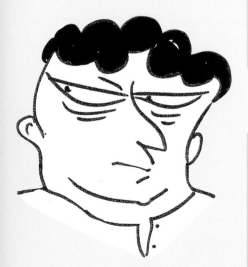

The side views of the head demonstrate how the shape of the mouth alters the sly look from calculating in the first cartoon to amusingly sly in the second and third cartoons.

Good use of angular lines in this face gives it a hard look. Notice no teeth are shown. The eye shape is different also.

Here the main point to notice is the narrowed slanted eyes with the pupils in the corners to give a furtive and sly look to the character.

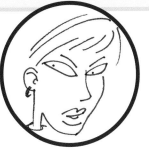

A variation on the sly look this time with gritted teeth on show. Also notice the extra line above the eye making an eyelid effect for more slyness!

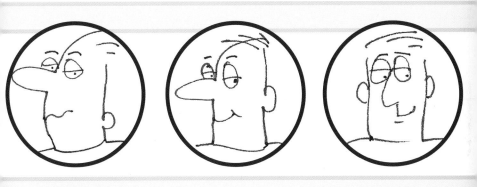

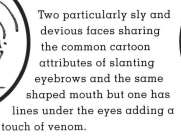

Two particularly sly and devious faces sharing the common cartoon attributes of slanting eyebrows and the same shaped mouth but one has lines under the eyes adding a touch of venom.

STUPIDITY

Depicting stupidity in a cartoon character allows you to use the full range of devices and techniques. Cartoons make a lot of people laugh at the stupid characters and the even more stupid antics they get up to so it is your job as a cartoonist to recognize the elements of linework that help make your characters look stupid.

Now here's an archetypal stupid-looking cartoon character—notice the dopey-looking eye due to the eyelid being half closed and the solitary front tooth, both ideal in the cartoon world for creating a hapless chap.

A dim-looking character is achieved by drawing lines below the eyes and giving him pursed lips.

Using a tiny circle for a mouth combined with double sloping eyebrows and half-closed eyes give this guy non-movie star looks!

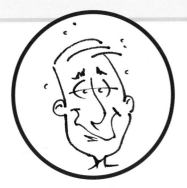

Here's another approach—look at how the eyes share a common eyelid that is half-closed to make the face look dopey. The crooked mouth line and sloping eyebrows plus the lines immediately under the eyes all contribute to this unfortunate character.

Using the same techniques as in the previous cartoon this has the addition of floating bubbles above the character's head that in cartoon terms indicates he is a bit stupid.

Placing an exclamation mark above the head helps to increase the look of puzzlement in a character.

The question mark above the head is another variation on giving a cartoon character a sense of confusion.

GLOSSARY

Anthropomorphism
The attribution of human characteristics to non-human things.

Artboard
Heavyweight paper used for drawing and painting. Bristol board is the best known type of artboard.

Art(work)
Any illustrative matter prepared for reproduction, such as illustrations.

Bézier curve
In object-oriented drawing applications, a mathematically defined curve between two points (Bézier points).

Bitmap
A text character or graphic image comprised of dots or pixels (picture elements) in a grid. Together, these pixels—which can be black, white, or colored— make up the image.

Body language
The gestures, movements, poses, and expressions that a person uses to communicate.

Caricature
Ludicrous exaggeration of the characteristic features of a subject.

Cartoon
1. A drawing intended as satire, caricature, or humor;
2. A simplistic, unrealistic portrayal.

Cliché
Something that has become overly familiar or commonplace.

CMYK
Cyan, magenta, yellow, and black—the inks used in four-color printing.

Color wheel
A circular diagram of the color spectrum used to show the relationships between the colors.

Copyright
The right of the creator of an original work to control the use of that work. Ownership of copyright does not always mean ownership of the work itself, nor does it necessarily cover worldwide rights.

Devices
A set of conventions used by cartoonists that act to represent actions, noises, and states of mind. They make things visible that are not physically present.

Dip pen
A pen, typically with a replaceable split sheet metal point, that must be repeatedly dipped into an external inkwell while writing or drawing.

Dots per inch (dpi)
The unit of measurement that represents the resolution of a device such as a printer, imagesetter, or monitor. The higher the dpi, the better the quality.

Fiber-tip pen
These have fine points made of a synthetic material and are available in a range of point sizes and colors. The ink may be water-soluble, in which case it can be blended with a brush. The more permanent inks tend to be alcohol based.

Flat color
An area of color in which there are no modulations of tone.

Foreshortening
A perspective technique used to create the illusion of an object receding into the background (or advancing into the foreground).

Fountain pen
A pen that is supplied with ink from a reservoir in its barrel.

Freehand
A drawing done without the help of any special equipment for accurately creating straight lines, circles, symbols, etc.

GIF
Stands for Graphic Interchange Format. A computer image format used for images with less than 256 colors. Good for bold graphics.

Graphics tablet
An input device that allows you to draw or write using a pen-like instrument as if you're working on paper.

gsm (grams per square meter)
A unit of measurement indicating the substance of paper on the basis of its weight, regardless of the sheet size.

Highlight
The brightest part of the subject.

Horizon line
The horizon line in perspective drawing is a horizontal line across the picture. It is always at eye level—its placement determines where we seem to be looking from, a high place or close to the ground.

Inking
Tracing over the rough pencil lines of a cartoon with ink.

JPEG
Stands for Joint Photographic Experts Group. A computer image format used for images with lots of colors or with a continuous tone.

Lettering
The drawing of letters to create text such as dialogue and captions.

Light box
A glass-topped box with a powerful light source. Used by cartoonists to trace artwork and inking.

Line work
Art work without shading or color added.

Manga
Refers to a variety of styles and influences from Japanese comics.

Outline
A line that marks the outer limits of an object or figure.

Palette
1. A dish or tray on which an artist lays out paint for mixing or thinning. May be made from wood, metal, plastic, or ceramic.
2. Also used to describe the range of colors a painter uses in a particular work.

Penciling
The step of roughing out a cartoon or comic to ensure the correct placement of drawings such as figures and backgrounds.

Perspective
Any graphic system that creates the impression of depth and three dimensions on a flat surface.

Pixels
Any of the small, discrete elements that together constitute an image on a computer or digital video screen.

Process white
An opaque white gouache used for correcting and masking artwork that is intended for reproduction.

Proportion
The harmonious relation of parts to each other or to the whole.

Props
The visual elements of a scene, apart from the setting and the characters. Usually objects and items used by characters.

RGB
Red, green, blue—additive colors.

Satire
A work in which human vice or folly is attacked through irony, derision, or wit. Satire is used to reveal flaws in human behavior or institutions with an intent to reform.

Scanner
An electronic device that converts artwork and transparencies into digital form so that they can be manipulated by a computer.

Shading
Graded markings that indicate areas of light or shade in a painting or drawing.

Sketch
A rough drawing, often made as a preliminary study.

Speech bubble

A (usually) circular shape used in cartoon drawing to indicate speech. Dialogue is written within the shape and a pointer designates the speaker.

Speed lines

A device used to indicate movement.

Stereotype

A standard mental picture that is held in common by members of a group and that represents an oversimplified opinion or prejudiced attitude.

Stick figure

A drawing showing the head of a human being or animal as a circle and all other parts as straight lines.

Technical pen

These pens generally utilize an ink-flow-regulating wire within a tubular nib, enabling them to produce precise, consistent ink lines without the application of pressure.

Thumbnails

Small rough layouts of cartoons used by some artists as a guide for the actual artwork.

Three-dimensional (3-D)

Giving the illusion of depth or varying distances.

TIFF

Stands for Tagged Image File Format—a computer image format used by most page layout and imaging programs for pictures; the files are easily compressed.

Two-dimensional (2-D)

A flat image, lacking in depth.

Vector graphics

A computer image made up of curves as created by drawing programs that use the PostScript language.

Viewpoint

The direction from which you look at something.

Wash

A method of creating tonal values in an image using watered down ink to create gray tones.

RESOURCES

Cartoon Organizations

Anonima Fumetti (Italian cartoonists' society)
Centro Nazionale del Fumetto
C.P. 3242
Ufficio Postale Marsigli
Torino
Italy
Tel: +39 011 433 1465
Email: segreteria@anonima
umetti.org
Web: www.anonima
umetti.org

Association of American Editorial Cartoonists (AAEC)
PO Box 37669
Raleigh
NC 27627
U.S.A.
Tel: +1 919 329 8129
Web: http://editorial
cartoonists.com/index.cfm

Australian Cartoonists' Association
PO Box 318
Strawberry Fields
NSW 2016
Australia
Tel: +61 1300 658 581
Web: www.abwac.org.au

The Cartoon Art Trust
c/o Wintle Ltd
New Burlington Place
London W1S 2HP
United Kingdom
Tel: +44 (20) 7287 2867
Email: cartooncentre@
freeuk.com
Web: www.cartooncentre.
com

The Federation of Cartoonists' Organizations
Reuchlinstrasse 17 A
70178 Stuttgart
Germany
Tel: +49 711 5283371
Email: mpohle.cartoons@
t-online.de
Web: www.fecoweb.org

Graphic Artists Guild
90 John Street
Suite 403
New York
NY 10038-3202
Tel: +1 212 719 3400
Email: admin@gag.org
Web: www.gag.org

Japanese Cartoonists' Association
1 – 4 – 6 Ginza
Chuo–Ku
Tokyo 104
Japan
Web: www.nihonmanga
kakyokai.or.jp

La Maison des Auteurs de Bande Dessinée (French cartoonists' society)
Web: www.mdabd.com

Further Reading

Anatomy for Fantasy Artists, Glen Fabry, Ben Cormack (Barron's Educational Series, 2005)

The Animator's Survival Kit, Richard Williams (Faber & Faber, 2002)

The Art of Making Comic Books, Michael Morgan Pellowski, Howard Bender (First Avenue Editions, 1995)

Cartooning for the Beginner, Christopher Hart (Watson-Guptill Publications, 2000)

Cartooning with The Simpsons, Matt Groening, Bill Morrison (Harper Paperbacks, 1993)

The Complete Cartooning Course: Principles, Practices, Techniques, Brad Brooks, Tim Pilcher, Steve Edgell (Barron's Educational Series, 2001)

Drawing and Cartooning 1,001 Figures in Action, Dick Gautier (Perigee, 1994)

Drawing and Cartooning for Laughs, Jack Hamm (Perigee, 1990)

Duane Barnhart's Cartooning Basics: Creating the Characters, Duane and Angie Barnhart (Cartoon Connections Press, 1997)

INDEX

CREDITS

Quarto would like to thank the following artists for supplying work reproduced in this book:

Nick Abadzis, Julie Anderson, Roger Armstrong, Rachel Ball, Tony Banks, Preston Blair, Sian Burston, Joanna Cameron, Paul Campion, Janie Coath, Gary Cross, Nina Davies, Selina Dean, Jane Dennis, Bojan M! Djukic, Simon Ellinas, Carl Flint, Russell Harvey, Bill Hewison, Jack Keely, Dave Kemp, David Lewis, Peter Maddocks, Hassan Moustafa, Ed Nofziger, Woodrow Phoenix, Dan Ruscito, Paul "Mooncat" Schroeder, Hayden Scott-Baron, Ian Sidaway, Catherine Slade, Ross Thomson, Anne Tout, Carson Van Osten, Laura Watton, Anne Wehrley and Steve Whitaker.

All other illustrations and photographs are the copyright of Quarto Publishing plc. While every effort has been made to credit contributors, Quarto would like to apologize should there have been any omissions or errors—and would be pleased to make the appropriate correction for future editions of the book.